POSTCARD HISTORY SERIES

Las Vegas
1905–1965

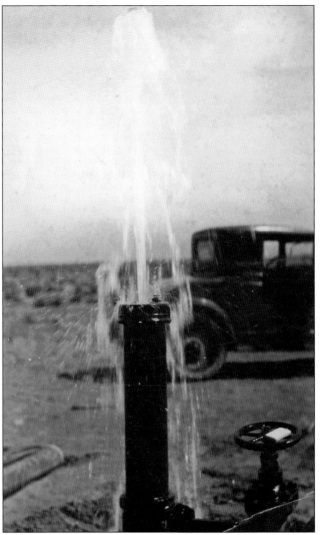

Water was the reason that Las Vegas was founded. It could provide water for the railroad and for the workers who would live in the town and support the railroad. The land auction of 1905 brought more than railroad workers to Las Vegas. In those early years, the residents of Las Vegas enjoyed an abundance of water. (Nevada State Museum, Las Vegas [NSM, LV].)

ON THE FRONT COVER: Fremont Street is pictured in the postwar era. The neon signs are bigger, brighter, and invite one to come in and try a hand with "Lady Luck." Compared to only 20 years earlier, when this section of the street was mainly retail shops and restaurants, now the street has given way to gambling halls and casinos. The street is entering the era of "Glitter Gulch." (NSM, LV.)

ON THE BACK COVER: Entertainer Joe E. Lewis explores the Wild West at the El Rancho Las Vegas and, as the excerpt on the back states, "When not playing cowboy, Mr. Lewis can be found playing other games at the casino. When the dice turn cold, he goes into the Opera House for 2 shows nightly (3 on Saturday) with Austin Mack at the piano." (NSM, LV.)

POSTCARD HISTORY SERIES

Las Vegas
1905–1965

Lynn M. Zook, Allen Sandquist, and Carey Burke

ARCADIA
PUBLISHING

Published by Arcadia Publishing
Charleston SC, Chicago IL, Portsmouth NH, San Francisco CA

Printed in the United States of America

Library of Congress Catalog Card Number: 2008936808

For all general information contact Arcadia Publishing at:
Telephone 843-853-2070
Fax 843-853-0044
E-mail sales@arcadiapublishing.com
For customer service and orders:
Toll-Free 1-888-313-2665

Visit us on the Internet at www.arcadiapublishing.com

The authors would like to dedicate this book to Dan Zook and Jon Stromp; Harvey Fuller; Rena, Don, and Deanna Sandquist; and James Campiglia.

CONTENTS

Acknowledgments 6

Introduction 7

1. Early Days 9

2. Fremont Street 15

3. Community 35

4. Motels 47

5. Roadside Architecture 53

6. Postwar 71

7. Las Vegas Strip 89

Bibliography 127

ACKNOWLEDGMENTS

All images used in this book come from the private collections of coauthors Carey Burke and Allen Sandquist unless otherwise noted. While the majority of the images come from these two collections, we were fortunate to have access to the postcard collection at the Nevada State Museum, Las Vegas (NSM, LV) as well.

The authors would like to thank Dennis McBride, curator of history, at the Nevada State Museum, Las Vegas for his support and help in providing images for this book. We would also like to thank David Millman, the director of the Nevada State Museum, Las Vegas and the staff for their continued support of this project. The Friends of Classic Las Vegas also provided support and assistance in identifying some of the more obscure images, and we would like to thank them for all their help.

We would also like to acknowledge the assistance of Judy Dixon-Gabaldon for proofreading and correcting our grammatical mistakes.

INTRODUCTION

Las Vegas is the largest city built in the 20th century. From its humble beginnings at a land auction in 1905, no one ever imagined that it would grow into an internationally known destination and effectively become the metropolis of the 21st century.

Because it is such a young city, it has been possible for much of its landscape to be captured over the years in picture postcards. These postcards remind one not only of a simpler time, but they have also captured, for posterity, the images of many places that no longer exist. In a city that seems to constantly reinvent itself, it can often be difficult to find the past. Yet, in many places throughout the city, the past can be found peeping out from behind modern facades and sometimes standing majestically amid small neighborhoods, bearing witness to a past that has often almost faded into oblivion.

These postcards stand as a historical reminder that Las Vegas did not spring fully formed from the mind of Benjamin "Bugsy" Siegel while gripped by a feverish dream. They show that, from the beginning, Las Vegas was a town inhabited by people dedicated to carving a community out of the harsh desert climate.

The postcards remind one of the evolution of this one-time dusty railroad town into the entertainment capital of the world, where neon and showgirls became the iconic symbols of America's playground. They bear witness to the changes in America's culture and the lure of roadside signage and attractions in that halcyon post–World War II era when Americans were encouraged to "see the U.S.A. in their Chevrolets."

Looking at these postcards, one can see how resort hotels have changed over the last 50 years as tastes and styles have evolved. The original Las Vegas Strip hotels seem almost quaint by today's mega-resort standards. Yet, one must keep in mind that in their day, they were considered luxurious hotels that catered to everyone from high rollers to the average tourist. The marquees of the hotels boasted the biggest names in entertainment; and as the images display, every hotel had an A-list entertainer playing in their showroom. While the majority of these original hotels have been imploded from the landscape, these postcards stand as a testament to the unique history of Las Vegas.

One must keep in mind, however, that Las Vegas has always been much more than just America's playground. It is a town where people have from the beginning raised their families and discovered their American dreams, all in the shadow of gambling halls and saloons. Were it not for these stalwart pioneers and their families, the history and the face of Las Vegas would be different indeed.

The intention of this book is to chart not only the well-known history of Fremont Street and the Las Vegas Strip, but to also highlight the lesser-known history of a Las Vegas filled with churches, schools, and other civic buildings.

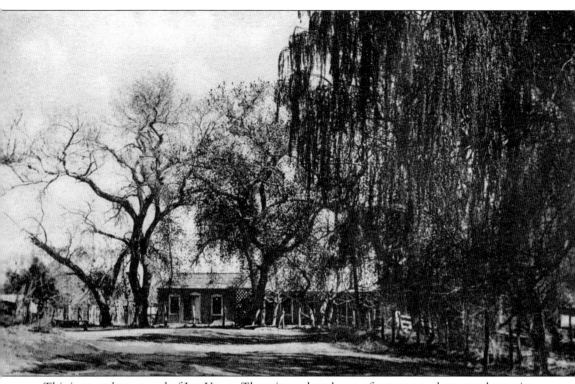

This is an early postcard of Las Vegas. There is an abundance of cottonwood trees and weeping willows shading the property. Life was harsh in those days before air-conditioning, and shade trees made it easier to endure the summer heat. (NSM, LV.)

One

EARLY DAYS

Las Vegas was founded in May 1905. Sen. William Clark of Montana had purchased the 1,800-acre Stewart Ranch from pioneer Helen Stewart in 1902 with the intent that Las Vegas would be a watering stop for the rail line he was building—the San Pedro, Los Angeles, and Salt Lake Railroad. When the rail line was completed in January 1905, Clark had the town site laid out, and plans were readied for a land auction.

The Las Vegas Land and Water Company was in charge of the auction. The railroad offered special rates from both Los Angeles, California, and Salt Lake City, Utah. Passengers could use their fares to help pay for their land.

On May 15, 1905, amid temperatures that climbed well over 100 degrees, more than 1,000 people gathered near a wooden platform just east of the train depot. At 10:00 a.m. bidding began. Prices ranged from $100 to $500 for residential lots. Corner lots ran as high as $750. The railroad also guaranteed that buyers would have access to the rail yards.

Fremont Street was considered the best location for businesses, and many of these lots went for top dollar. Not all the lots were sold on that day, and the auction resumed the following morning.

There were restrictions on the lots. Liquor sales were prohibited except on Blocks 16 and 17. So those two blocks were quickly filled with saloons and houses of ill repute.

The little community went to work as businesses and homes began to spring up not only on Fremont Street, but on the side streets as well.

Across from the train depot, two hotels were built, as well as restaurants that catered to the train passengers.

The men and women who pioneered the town site knew that they had their work cut out for them: to carve a community and home out of the dirt and heat of the desert.

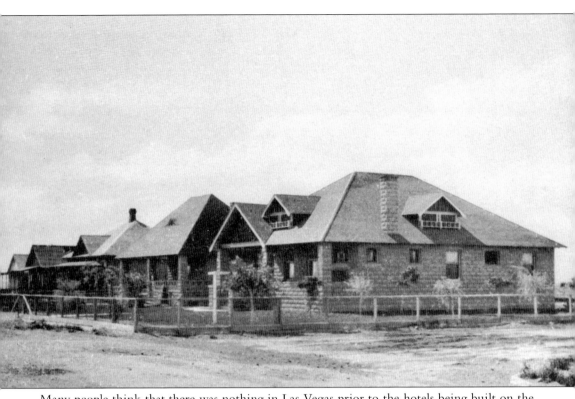

Many people think that there was nothing in Las Vegas prior to the hotels being built on the Las Vegas Strip. The story of the land auction and the community that was carved out of the desert gets lost in the myths of Bugsy Siegel and the mob. Of course, those are colorful myths. People really lived in Las Vegas from the beginning. The first house was built by Chris Brown. It was later owned by Fred Siebert, whose wife was sister to Gov. Tasker Oddie. The second house was owned by Charles "Pop" Squires. Squires was the publisher of the *Las Vegas Age* newspaper. His wife, Delphine, was a founding member of the Mesquite Club, one of the first service organizations. Many of the Mesquite Club's functions were held here. The Squires were a beloved pioneer family. The third house was occupied by Nickolas and Hazel Williams. These houses stood on what is now the southeast corner of Fourth and Fremont Streets. Today it is where Fitzgerald's Casino stands. (NSM, LV.)

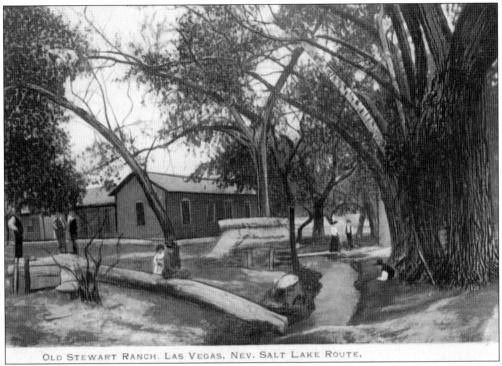

OLD STEWART RANCH. LAS VEGAS, NEV. SALT LAKE ROUTE.

This is the Stewart Ranch. It was also a way station for travelers crossing the desert. Archibald and Helen J. Stewart had taken over the ranch and turned it into a success. After Archibald was killed, Helen and her children continued to live here. She finally sold the ranch and the water rights to Sen. William Clark. (NSM, LV.)

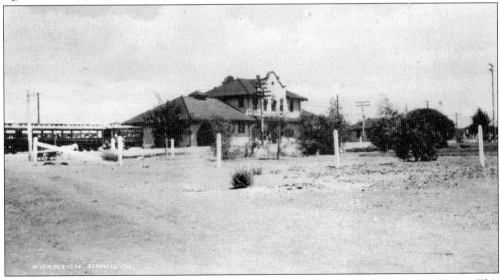

This Spanish Mission–style structure was the first permanent train depot in Las Vegas. This 1913 postcard dates to when the building was the depot for the San Pedro, Los Angeles, and Salt Lake Railroad. This depot was torn down in the 1940s and was replaced with a Streamline Moderne–style building. That depot was torn down in the late 1960s to make room for the Union Plaza Hotel. (NSM, LV.)

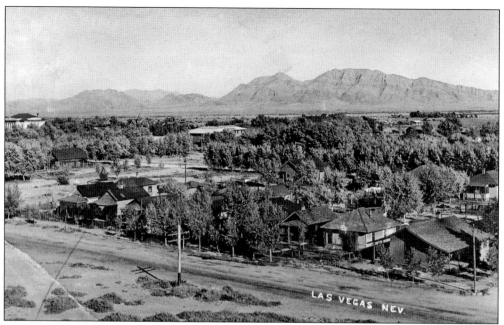

This early photograph of Las Vegas shows not only homes, but also an abundance of cottonwood trees. Water was the life force of the community in those early years. This postcard is of Main Street, just south of Fremont Street. In a few years, this will be a bustling part of town. (NSM, LV.)

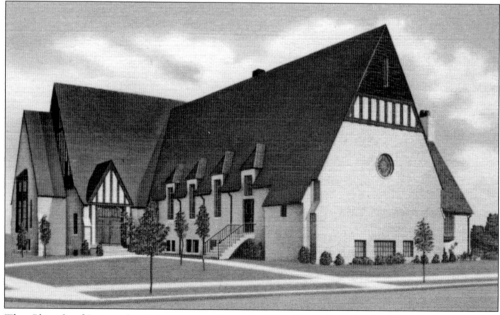

The Church of Latter-day Saints originally settled Las Vegas back in the 1850s. However, the harsh living conditions caused them to abandon the fort they had built and return to Utah. After the land auction, many Mormons moved to Las Vegas. This is one of the first churches built for their faith. However, there were other faiths practiced in the community. (NSM, LV.)

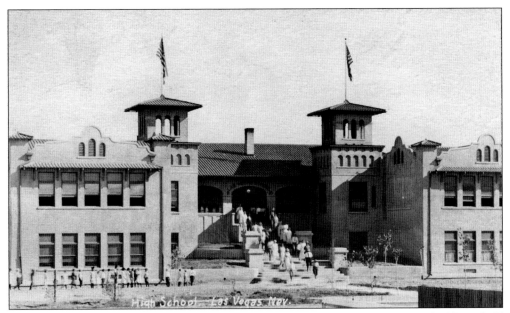

In 1910, the cornerstone was laid for the Fifth Street School. Previously classes had been held in wooden structures, but they burned down, and the citizens realized the need for a more permanent school. When the school opened in 1911, it catered to all classes from elementary to high school. Students from remote areas of the valley were invited to stay with townsfolk for the duration of the school year. (NSM, LV.)

There was another fire, and the school burned again in 1935. It was decided that a new school would be built that would not be so prone to fire. The Spanish Mission style was still popular, and the design of the Fifth Street Grammar School included a red tile roof. It remained a school until the 1960s. It is being restored by the City of Las Vegas. (NSM, LV.)

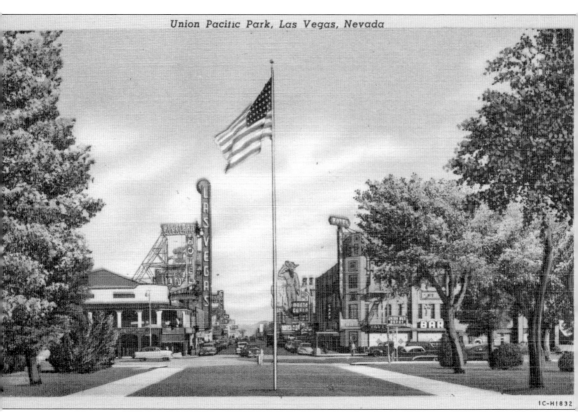

This is the park in front of the train depot. A circular drive goes around Union Park. Men by the hundreds camped out on the lawn awaiting jobs to work on the Hoover Dam. Teenagers would cruise up Fremont Street, then go around the circular drive and back down Fremont in a ritual called "Doing the Donut." When the train depot was demolished in the late 1960s, the park was destroyed as well. (NSM, LV.)

Two

FREMONT STREET

Fremont Street, from the beginning, was the main thoroughfare of early Las Vegas. At the western end, the street led into the circular drive that surrounded the train depot.

In those early years, the street was lined with small hotels, restaurants, and shops. Doctors, lawyers, and other professionals had their offices on the second floors of many of the businesses. At the time, there were no saloons because they were prohibited outside of the notorious red-light district known as Block 16. Instead, residences dotted the street.

Like other small towns around America in the early 20th century, Fremont Street was the "Main Street." Images from that era show a small town influenced by its Southwestern roots. The street was not paved until the mid-1930s and then only the first five blocks.

In 1931, the State of Nevada re-legalized gambling. In 1933, Thomas Young, of the Young Electric Sign Company (YESCO) from Salt Lake City, Utah, talked the owners of the Boulder Club into installing a simple neon sign on the front of their building. That sign would forever change the look of the friendly street, and as more and more people traveled to Las Vegas for gambling, Fremont Street began to develop larger gambling clubs.

In the postwar era, tourism took off, and nowhere was this more evident than on Fremont Street. Large gambling halls such as the Golden Nugget, the El Cortez, and the legendary Horseshoe Club all built elaborate neon facades. Tourists driving into town marveled at the sight, and Fremont Street became known as "Glitter Gulch." It was like entering a canyon of neon and flashing light bulbs that pulsated into the dark, heavenly sky above. The mid-20th-century look of the Mint Hotel, with its pink and white neon wave that crested over the entrance and then straight up the pylon sign, lighting the star at the top, captured the imagination and spirit of the eternal optimism that was so much a part of that era.

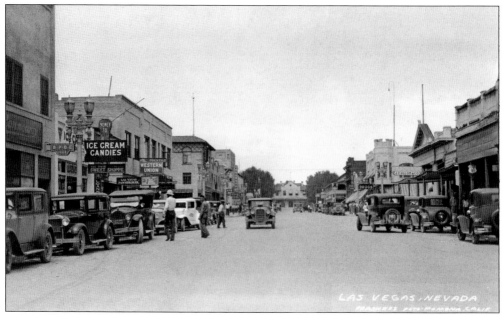

This is Fremont Street looking west around 1930. The train depot is at the end of the street. There were businesses catering to the local population. For the locals, it was their Main Street. There was an Elks lodge, an ice cream and sweets store, a Western Union, and a hardware store. Doctors, dentists, and lawyers had their offices on the second floors of many of the buildings. (NSM, LV.)

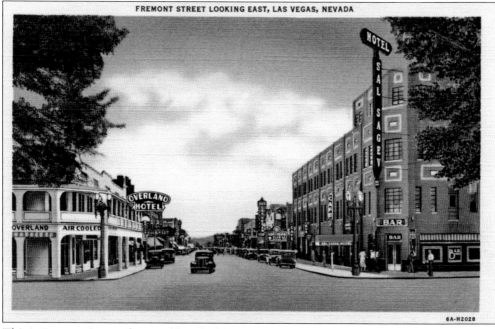

This is Fremont Street after gambling had been re-legalized. In the foreground are two hotels, the Overland and the Sal Sagev, which catered to visitors. The Overland was "air-cooled," but it was not air-conditioning. Rather, water was cooled by a fan much like a swamp cooler. Small gambling halls like the Northern Club, the Las Vegas Club, and the Boulder Club began taking over from the small retail businesses.

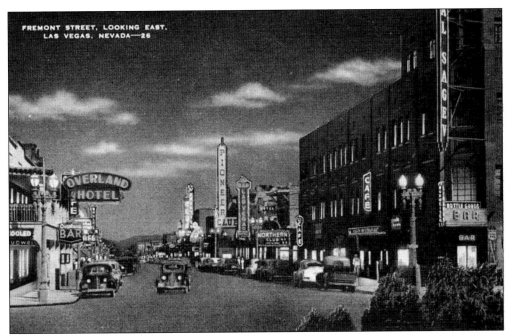

Here is a rare nighttime look at Fremont Street from this era. Neon, courtesy of the Young Electric Sign Company, had come to Las Vegas. The Pioneer Club has opened, but it does not yet have Vegas Vic. There were still plenty of cafes and retail and professional businesses on the street, but the gambling halls were beginning to grow in number.

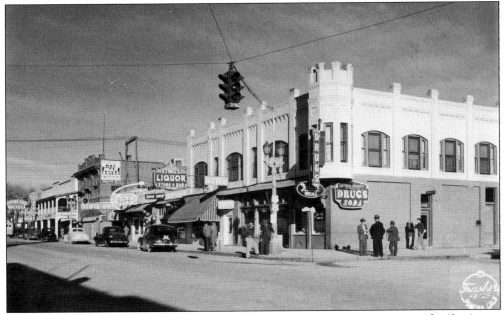

This castle-like structure is the Las Vegas Pharmacy. Owned by the Ferron family, it was the first pharmacy in Las Vegas. Originally housed in a basic wooden structure, it stood on the corner of First and Fremont Streets until the mid-1950s. It had a hotel upstairs above the pharmacy, the La Bonita. The building was torn down to make room for the Silver Palace. Today it is Mermaids. (NSM, LV.)

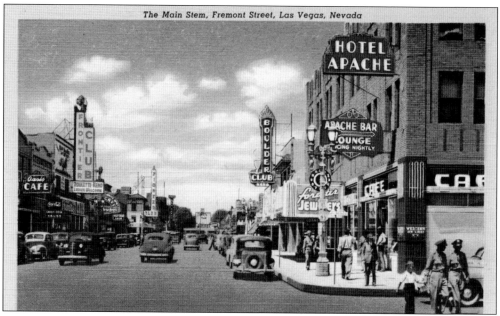

The Main Stem, Fremont Street, Las Vegas, Nevada

This view of Fremont Street looks west in the early 1940s. Two soldiers in the foreground cross Second Street with a young boy. Also in the foreground are the Hotel Apache and Forester Jewlers. As gambling continued to grow in popularity, even during World War II, more and more gambling halls popped up. Neon signage was used to attract the eye and the gamblers' pocketbooks. Today Binions is at this corner.

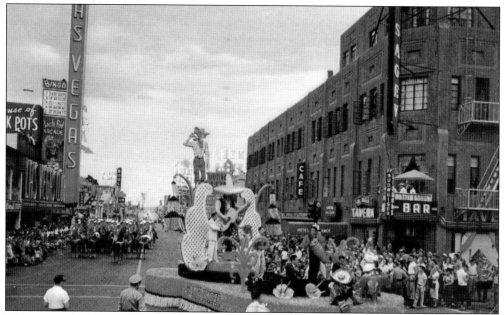

This 1950s photograph shows Fremont Street along with the Helldorado Parade. Helldorado was a major event that celebrated the town's Western roots and heritage. There were three parades over three days, culminating in the famed Beauty Parade. Las Vegas Strip hotels and local businesses sponsored elaborate floats that rivaled the Rose Parade at the time. Tourists came to town to partake in the yearly celebration and for the chance to dress like a cowboy.

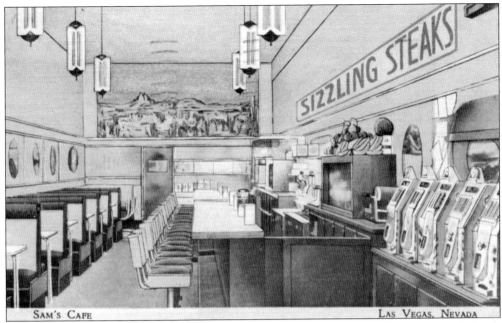

Though gambling continued to grow, restaurants were also popular. Catering to both locals and visitors, many of them stayed open late. This is a postcard of Sam's Café. What stands out is the sign proclaiming "Sizzling Steaks" and the row of slot machines. It was located on Fremont Street near the El Portal movie theater and became quite a hangout for local teenagers. (NSM, LV.)

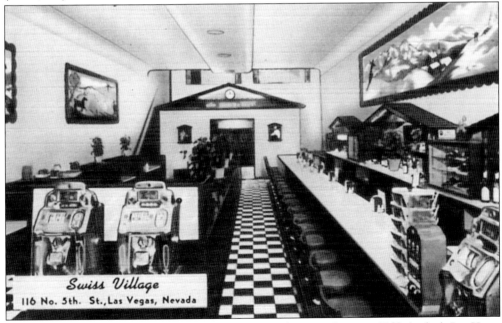

The Swiss Village was across the street from the Modern Market near Fifth (today's Las Vegas Boulevard) and Fremont Streets. It was a two-story restaurant. The stairs in the back led to a balcony overlooking the restaurant. Teenagers liked to sit up there so that they could see who came in. The three slot machines were a good way to get rid of extra change. (NSM, LV.)

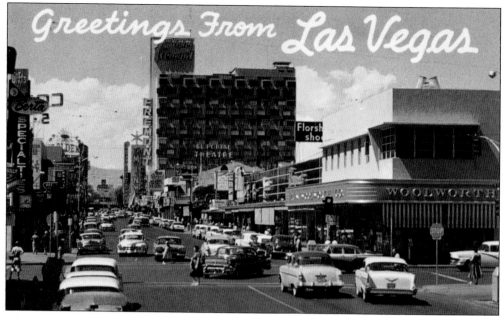

This is the intersection of Fifth and Fremont Streets. Today Fifth is known as Las Vegas Boulevard. There is a Woolworth's anchoring the corner. With its shiny, wraparound, Streamline Moderne front proclaiming 5, 10, and 25¢, and its name in the terrazzo sidewalk at the front door, it was a beauty to behold. Woolworth's opened in 1948 and remained on Fremont Street until 1997, when it finally closed.

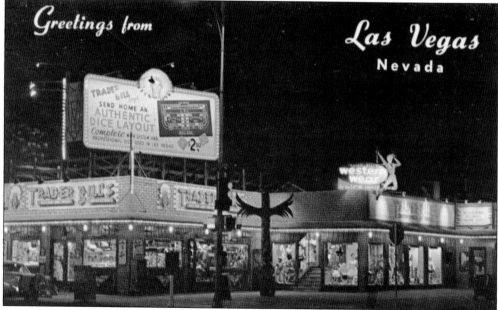

Trader Bill's was a store that specialized in Western wear and leather goods. It was located at the northwest corner of Fourth and Fremont Streets near Sam's Café. At Helldorado time, locals packed the place, buying their accessories for the celebration. Tourists enjoyed the authentic Indian blankets, leather goods, and turquoise that were offered for sale. A large neon arrow emblazed with "Trader Bill's" was added later.

The Boulder Club was the first establishment on Fremont Street to have a neon sign. The original was a tall, vertical, neon sign with a modified zigzag, modern crest about 10 feet off the roofline. After the completion of the Hoover Dam, the sign incorporated a neon facade of the face of the dam on the marquee of the building. In 1960, the Boulder Club was destroyed by fire.

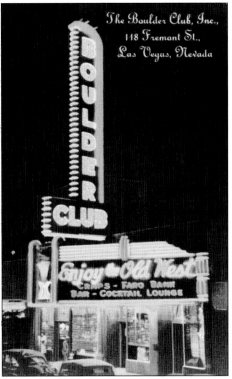

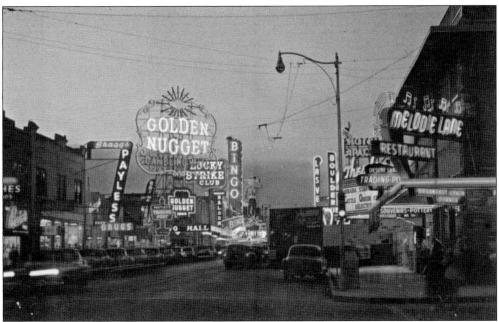

Fremont Street in the early 1950s reveals a scene that caters to gambling and to the needs of the locals. The Melody Lane Restaurant in the forefront was a popular teen hangout. With its brightly lit, dancing note neon sign, it advertised breakfast, lunch, and dinner. Across the street is Skaggs Drugs. Trading posts such as the Desert Sands Pottery were also popular with locals and tourists alike. (NSM, LV.)

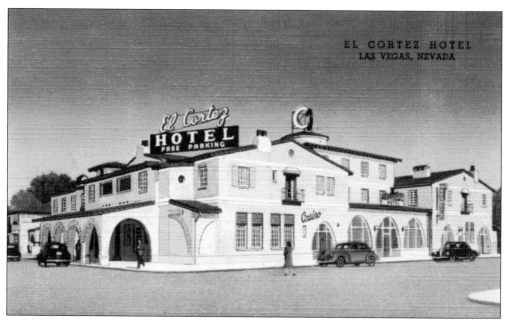

The El Cortez at Sixth and Fremont Streets is farther away from most of the casinos on Fremont Street. It was owned by J. Kell Houssels Sr., a local businessman. He hired architect Wayne McAllister to design the hotel and casino. It opened in 1941 with 59 rooms. Shortly after it opened, Benjamin "Bugsy" Siegel muscled his way into owning the race wire at the El Cortez before casting his eye farther south on the Flamingo Hotel out on Highway 91. In 1963, Jackie Gaughan bought the hotel and casino. The El Cortez is still part of Fremont Street and is still owned, in part, by the Gaughan family. These two postcards show how the building adapted the neon signage on its front marquee and rooftop without altering the look of the building. Today the building still retains its original design.

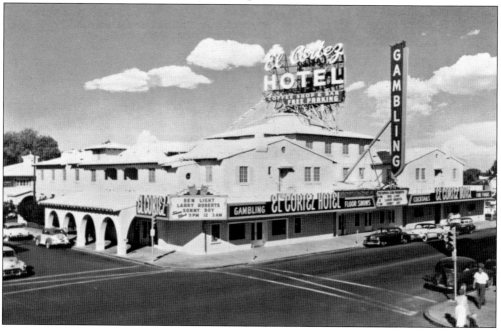

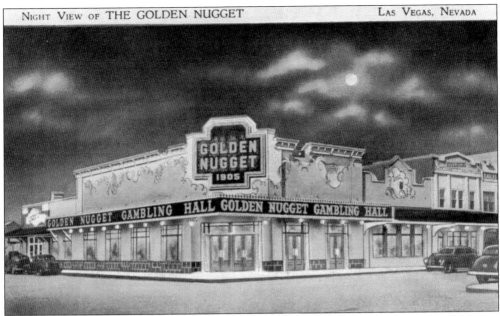

The Golden Nugget sits on the south side of Fremont Street between First and Second (Casino Center) Streets. It originally occupied the southwest corner at Second and Fremont. Its original neon signage that incorporated the date of 1905 led many to believe that it had been built in 1905. But in reality, it did not open until the late 1940s. Its famed bullnose and Victorian era–inspired rooftop signage was designed by YESCO neon designers Kermit Wayne and Hermon Boergne. The brightly lit front was instrumental in turning Fremont Street into Glitter Gulch, and the Golden Nugget became one of the most photographed signs in the world. Steve Wynn bought the property and gave the building a total makeover before selling it. Today the facade that made it famous has been replaced with a modern, stately look.

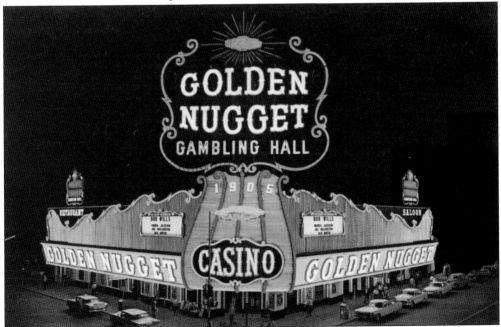

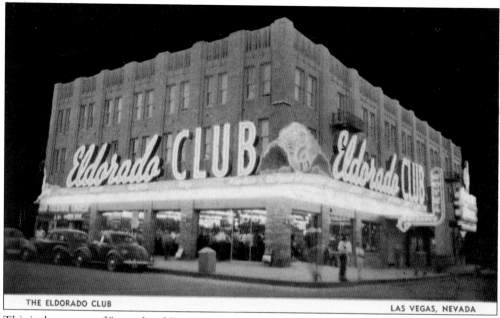

THE ELDORADO CLUB LAS VEGAS, NEVADA

This is the corner of Second and Fremont Streets. It opened in 1932 as the Hotel Apache and had the first elevator in town. Over the years, the street level became a casino with many different names. That all changed in 1951 when a larger-than-life Texan, Benny Binion, bought the El Dorado Club and renamed it the Horseshoe Club. From the beginning, the Horseshoe Club was a family owned and operated casino. Binion ran afoul of the government and went to prison in 1953 for tax evasion. During that time it was owned by local businessman Joe W. Brown. Once Binion returned, he bought back the Horseshoe Club and in 1962 hired YESCO to design a neon facade for the building. Because of his time in prison, Binion was not allowed to have a gaming license, but everyone knew he was in charge of the Horseshoe.

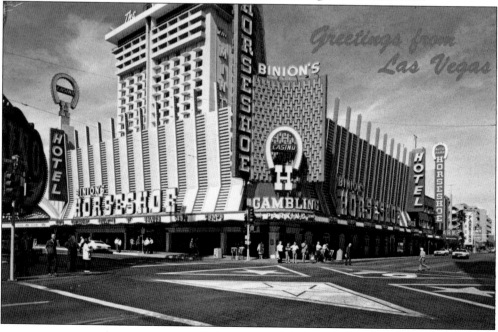

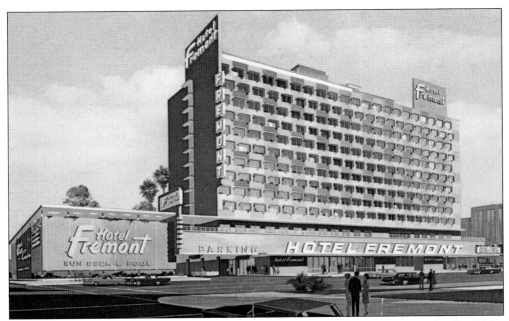

The Fremont Hotel was designed by famed architect Wayne McAllister. It was the first high-rise hotel to be built on Fremont Street. Soaring 13 stories above the street, the Fremont was, for a while, the tallest building in the state. It opened on May 18, 1956, and the entire town was invited to its celebration. With its mid-20th-century modern look, it was a break with the Western look of most of the casinos around it.

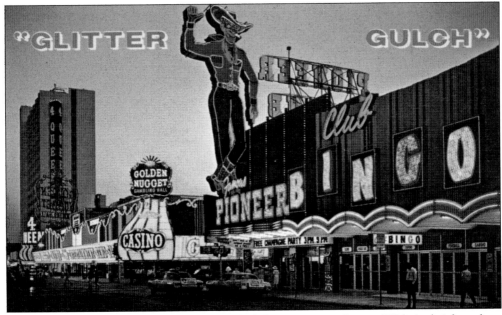

Beginning in the 1950s, neon signage exploded on Fremont Street. With its bright colors, which often incorporated chaser lights and flicker bulbs as well, Fremont Street became famous as Glitter Gulch. As more and more casinos incorporated neon into their facades, it became a light show that lasted from dusk to dawn. Vegas Vic, the cowboy in the center of this postcard, is landmark in Las Vegas to this day.

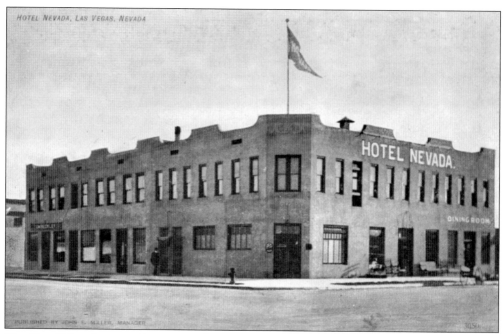

The Hotel Nevada sat on the corner of Main and Fremont Streets across the street from Union Park and the train depot. It opened as a tent hotel to accommodate men who came for the 1905 land auction. By 1906, it was this imposing brick structure. Telephone service came to Las Vegas in 1907, and the hotel had one of the first telephones. In the early 1930s, it became the Sal Sagev (Las Vegas spelled backward) Hotel. In 1955, the street level was leased by a group from San Francisco who planned to open a new casino, the Golden Gate. The Golden Gate casino flourished. Due to its location, it is featured in a number of Hollywood films, including *Viva Las Vegas* and *Diamonds are Forever*. (Above, NSM, LV.)

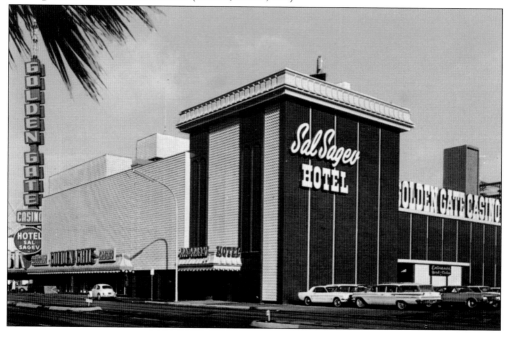

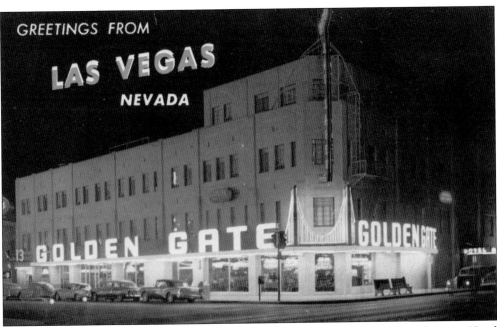

The arrangement between the owners of the Golden Gate casino and the Sal Sagev Hotel lasted until 1974 when the Golden Gate owners bought the building. It became the Golden Gate Hotel and Casino. Over the years, the neon signage has gone through many changes. The dancing letters of the pylon sign now include a neon facade of the famed Golden Gate Bridge. In the back of the building is a neon entrance sign that dates back to its days as the Sal Sagev. There is also a blue neon sign in script that spells out "Restaurant" that dates back to the 1940s. Today the Golden Gate has restored the original facade and continues to operate at 1 Fremont Street.

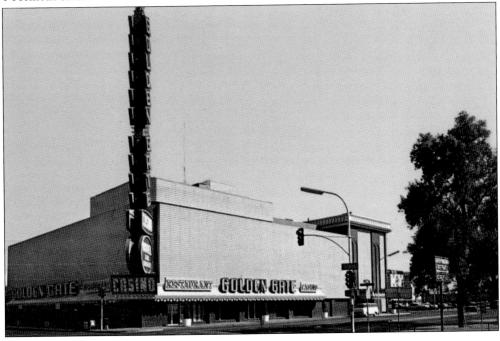

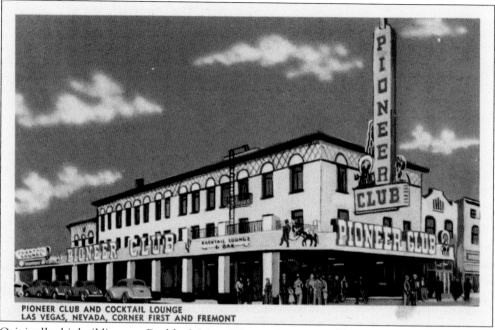

PIONEER CLUB AND COCKTAIL LOUNGE
LAS VEGAS, NEVADA, CORNER FIRST AND FREMONT

Originally this building was Beckley's Mens Wear and was owned by pioneer William Beckley, who had come for the land auction. The upper floors were used as a community gathering spot in the early years. In the late 1940s, Beckley leased the street level to the owners of the Pioneer Club. Today the Pioneer Club is a souvenir shop, and its neon facade remains, although it is endangered.

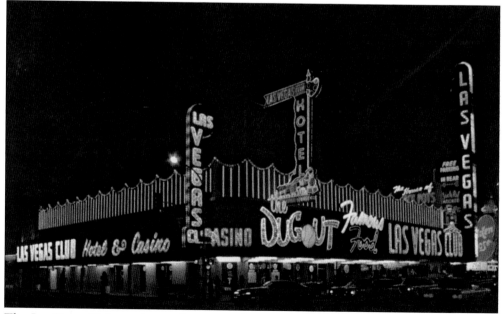

The Las Vegas Club on the north corner of Main and Fremont Streets was originally the Overland Hotel. In the late 1940s, Kell Houssels moved his Las Vegas Club across the street to this location. He kept the Overland Hotel on the upper floors. In 1961, Jackie Gaughan and Mel Exber bought the Las Vegas Club and redid the facade, adding more neon.

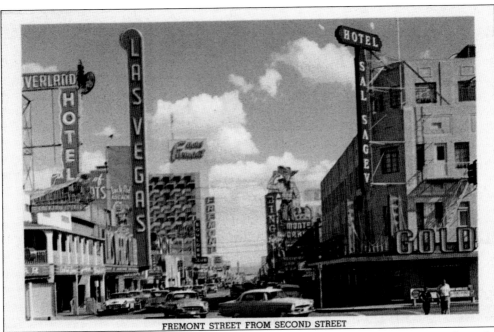

FREMONT STREET FROM SECOND STREET

Although it states otherwise, the image above really looks east on Fremont Street from the corner of Main Street. In the years before the canopy was erected over Fremont, the street was a main thoroughfare for tourists and locals alike. The Monte Carlo Club was originally the Northern Club and was owned by Mayme Stocker, who had received the first gaming license in 1931. She leased the Monte Carlo to a young Wilbur Clark. The neon signage of the Overland Hotel included a neon train as a way to attract passengers arriving at the train depot across the street. A bit of the circular drive around Union Park can be seen in the foreground.

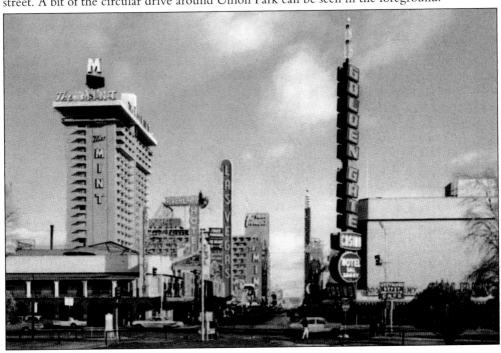

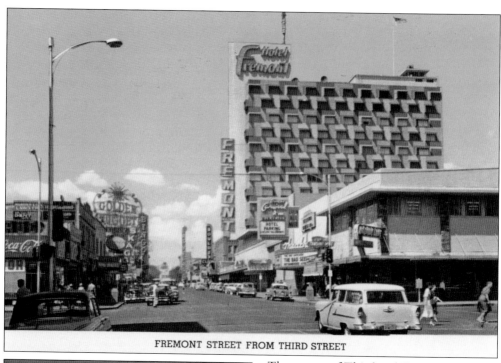

FREMONT STREET FROM THIRD STREET

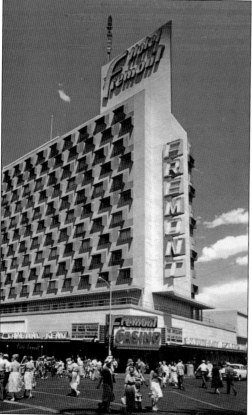

The corner of Third and Fremont Streets reflects the retail and professional businesses that the locals depended on. On the corner is the Fremont Medical Building. Behind it is the Fremont Theater. There were not many movie theaters in Las Vegas at that time, and most of them were in the downtown area. The Fremont Theater was where many major movies premiered when they came to town.

This is the intersection of Second and Fremont Streets. A Shell gas station stood at this corner, with a Wimpy's Drive-In next door, until both were demolished for the Fremont Hotel in 1955. A young Wayne Newton and his brother Jerry got their first big break at the Fremont. Too young to be allowed into the casino during breaks, the brothers had to leave the hotel between shows.

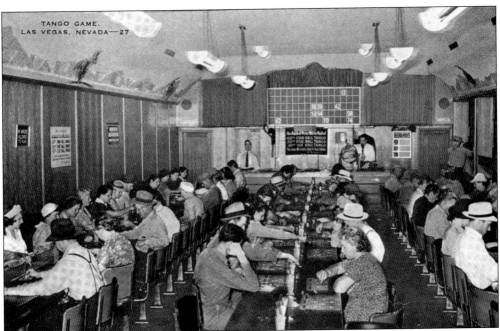

Gambling on Fremont Street was a lure not only to tourists but locals alike. Games of chance such as roulette, faro, fan-tan, tango, and keno were popular. Tango was a game similar to keno and bingo, and many of the smaller clubs on Fremont Street had an area just for tango. It was a cheap game of chance that people could play for hours without losing their shirts.

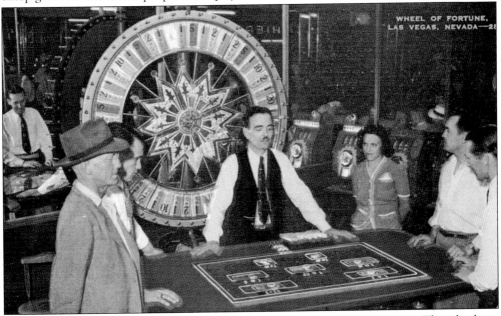

WHEEL OF FORTUNE,
LAS VEGAS, NEVADA—28

The Wheel of Fortune was a gambling game that dated back to the Wild West. The wheel was divided into a number of equal segments separated by spokes. Each segment was associated with a number. The dealer spun the wheel. The winning segment was indicated by a pointer on a flexible piece of leather. The leather rubbed against the spokes, creating friction that slowed the wheel down until it came to a complete stop.

31

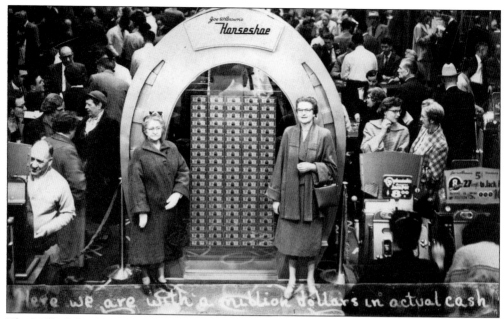

The Million Dollar Display at the Horseshoe Club was a major tourist attraction. Folks could have their picture taken at the display and then send the picture postcard to friends or family showing them having a great time in Las Vegas. The display consisted of one hundred $10,000 bills stacked 20 high and 5 across.

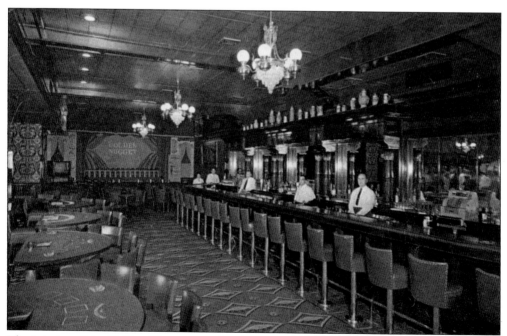

The interior of the Golden Nugget reveals what the gambling casinos once looked like. Today it is all about state-of-the-art equipment. In an earlier age, it was more about the experience in comfortable surroundings. By conjuring up the Barbary Coast, with its crystal chandeliers and mahogany and leather, gamblers felt like they were transported back to the Wild West.

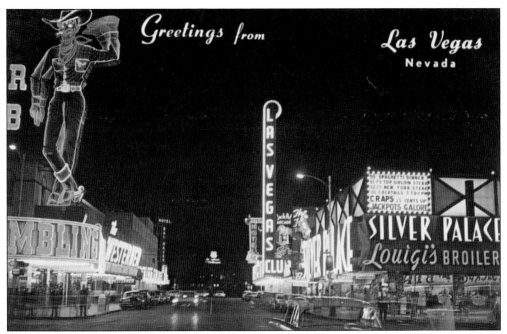

With neon cowboy Vegas Vic perched atop the Pioneer Club and riding high above the street, Fremont Street takes on a different look after dark. With neon pulsating into the heavens for four blocks, Fremont becomes like no other street. Everywhere light is moving and inviting one to come in.

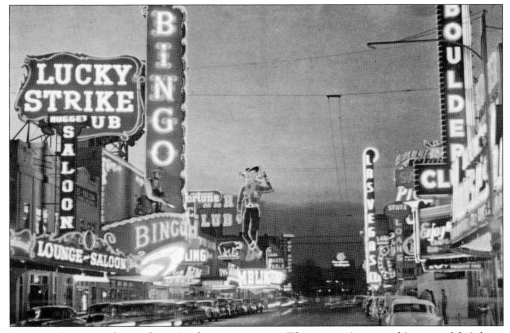

Fremont Street is shown here in the postwar era. The neon signs are bigger and brighter. Compared to only 20 years earlier, when this section of the street was mainly retail shops and restaurants, now the street has given way to gambling halls and casinos. The street is entering the era of Glitter Gulch.

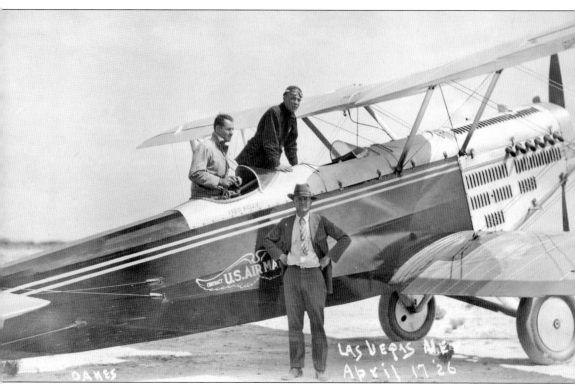

The first airmail pick-up in Las Vegas was on April 17, 1926. Local businessman Bob Griffith is standing next to the airplane. The inscription reads, "This postcard should go out on the first air mail plane to leave Las Vegas for the West, 2:30 pm today. Everybody will be out to see them change mail and get away." The airfield was located near where the Sahara Hotel is located today. (NSM, LV.)

Three

COMMUNITY

More than any other city, Las Vegas has long had the reputation of being the place to go for reinvention. From its humble land auction beginnings in 1905, people came to Las Vegas with an eye toward starting their lives over. Long before the gambling, neon, and showgirls were even a thought, Las Vegas was a small town like thousands of others scattered across the country.

The settlers had all come from someplace else to this small town along the railroad. They had left behind not only their families, but also all the trappings that make a community. Once here, they realized that they would not only be starting over, but that they would also have to build and establish those things that make up a community, including schools, churches, auditoriums, and post offices.

Most people do not associate religion with Las Vegas, but the early pioneers of the city were people of different faiths, and they set out to build places of worship. They also saw the need early on for schools as their children grew up.

In the midst of the Depression, two wonderful buildings were constructed. The original Las Vegas High School was championed by Maude Frazier, who realized that with the growing population a high school would be needed. Many scoffed that there would never be enough students to fill the school. But with the building of the Hoover Dam, the children of the men working on the dam were bused into Las Vegas for school. The school quickly began to fill.

A post office was also needed, and a wonderful three-story, Federalist-style building was constructed a few blocks from Fremont Street. The post office was located on the bottom floor, and the upper floors were used as the courthouse. It was here in the 1950s that Sen. Estes Kevaufer held his celebrated hearings on gambling.

Today both of these buildings are still standing. The high school is now a performing arts academy, and the post office is being renovated and will reopen as a museum.

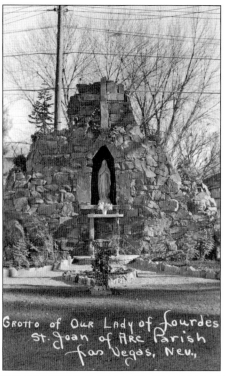

Pictured is the Grotto of Our Lady of Lourdes at St. Joan of Arc Parish. In the early years, a priest would travel from Salt Lake City, Utah, on a regular basis to offer Mass in a community hall. The parish was established in 1908. In 1939, a Catholic school was added. In 1941, local pioneer David Lorenzi constructed the grotto shrine as a place of solitude for those wishing to pray. (NSM, LV.)

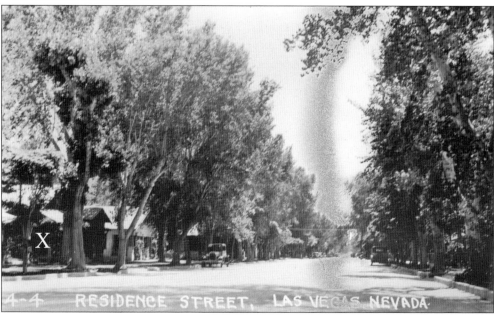

Notice all the mature trees providing shade on this residential street in Las Vegas. With construction underway on the Hoover Dam, Las Vegas became a growing community. Because the dam was one of the most publicized projects in the midst of the Depression, men flocked to Las Vegas looking for work. The "X" marks the home of Mayme Stocker, who received the first gaming license in 1931. This is a photo postcard of a typical residential street in Las Vegas during that era. (NSM, LV.)

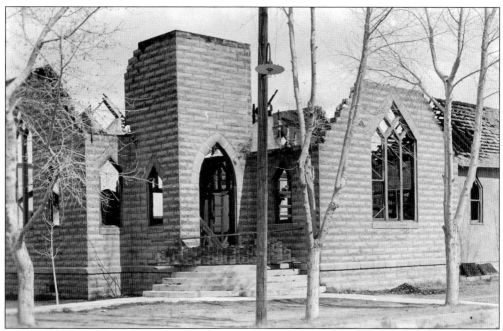

The Methodist church is shown here after a 1922 fire. The parishioners rebuilt the church and made it larger so that it could grow with the community. It was located at Third and Bridger Streets in the heart of downtown. While no longer a church, parts of the building are still standing. (NSM, LV.)

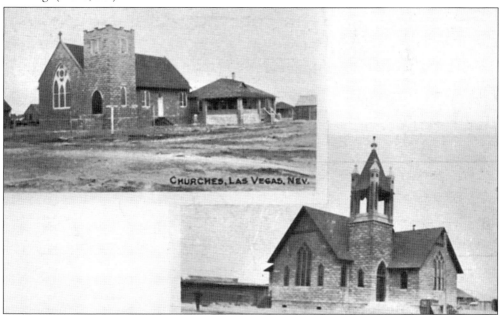

Fires destroyed a number of buildings in early Las Vegas. Many were originally constructed from wood, and the wood would dry out in the sun, making them more susceptible to fire. The original Christ Church Episcopal was built at Second and Carson Streets in 1908. The Episcopal church installed the first church bell in Southern Nevada in 1909. In 1954, the church was sold for $105,000. The Four Queens parking garage is now on the site. (NSM, LV.)

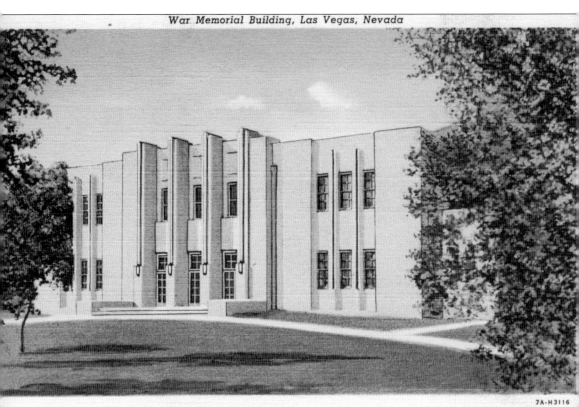

7A-H3116

The War Memorial Building was constructed because the various fraternal organizations believed there was a need for a convention center. The city donated the land, and the American Legion pledged $5,000 in honor of local veterans. However, the project remained at a standstill due to a lack of funds. The federal government, confident that the building would be a civic auditorium, supplied the remaining funds. Construction was done by the Works Progress Administration. The building was a gathering place for concerts, plays, and poetry readings. On October 13, 1952, at the height of the Red Scare and McCarthyism, Sen. Joe McCarthy came to speak against Communists in the government. He was shouted down by local newspaper publisher Hank Greenspun. The War Memorial Building was demolished to make way for the new city hall in the early 1970s. (NSM, LV.)

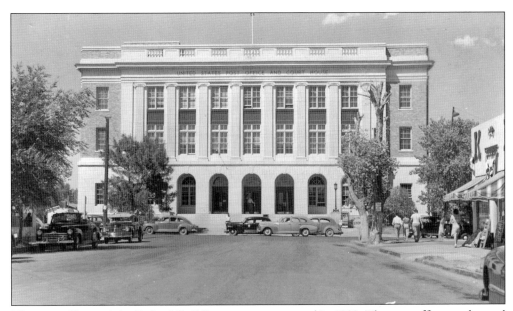

The post office and the Federal Building were constructed in 1933. The post office was located on the street level, with courtrooms on the floors above. In those days, it was still common to hold court on Saturday mornings. In 1950, the U.S. Senate created a committee to investigate organized crime in American life. It was headed by Tennessee senator Estes Kefauver. On November 15, 1950, Kefauver and the committee came to town. They held a marathon nine-hour hearing interrogating locals, including Moe Dalitz and some public officials, before leaving town. But before they left, they voiced their outrage at gambling in Las Vegas, conveniently overlooking the fact that it was legal to do so in the state. Today the building is being restored and will house a museum dedicated to the influence of organized crime on Southern Nevada. (Above, NSM, LV.)

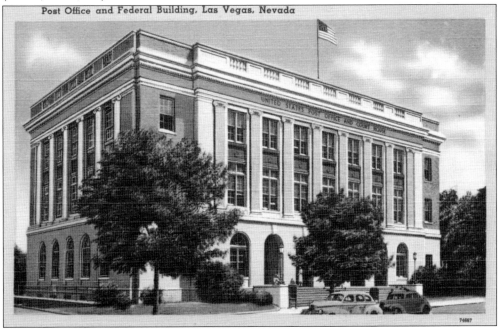

Post Office and Federal Building, Las Vegas, Nevada

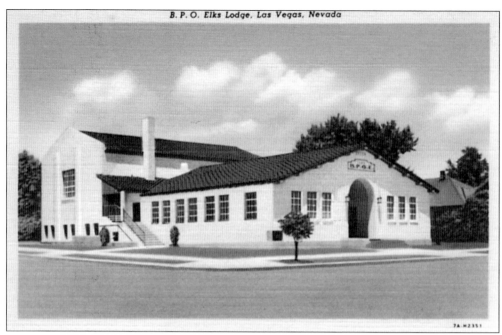

The Elks Lodge was near Fremont Street. The Elks were headed by one of the biggest civic boosters of young Las Vegas, "Big Jim" Cashman. When tourism began to wane in the months following the completion of work on the Hoover Dam, Cashman and the Elks created the Helldorado Days as a way to engage locals and draw tourists to town to celebrate its Wild West beginnings. (NSM, LV.)

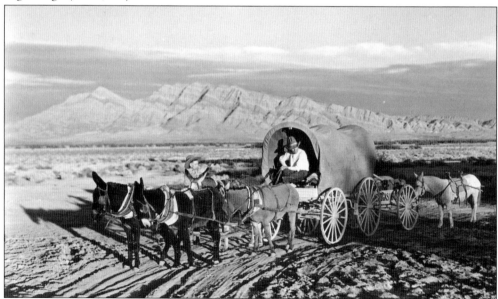

There were three parades during Helldorado Days: the Kid's Parade, the Old-Timers Parade, and the Beauty Parade. Everyone was encouraged to dress Western, and the men were encouraged to grow beards. The Old-Timers Parade was filled with old wagons, buckboards, mules, and anything that evoked the old West. The Western frontier had not been closed all that long when Las Vegas was founded, and many considered it a frontier town. (NSM, LV.)

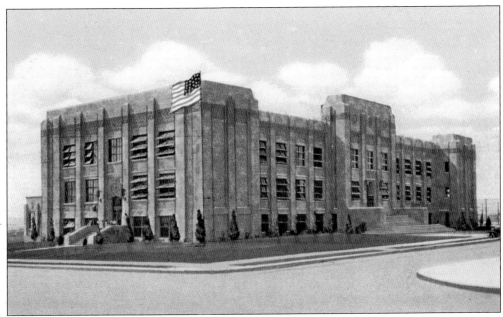

The Las Vegas High School was located at Seventh and Bridger Streets. When first built, many considered the school too far out of town. Critics said there would never be enough students to fill it. It opened in 1930 with room for 500 and quickly filled with students. With its beautiful art deco facade, the school quickly became a landmark. Today it is the Las Vegas Academy for the Performing Arts. (NSM, LV.)

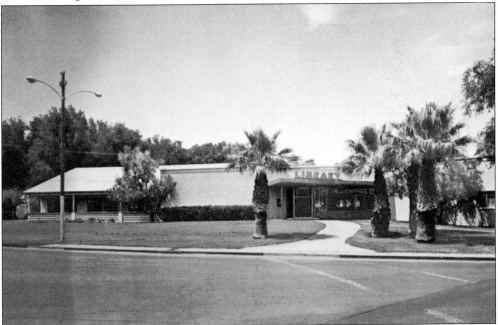

The Las Vegas Public Library was built at 400 East Mesquite Street in Squires Park. It was completed in the early 1950s. At the time, it was the largest library in the state of Nevada. Built and presented to the city by a group of public-spirited citizens, with the cooperation of service clubs and private individuals, it was a success from the start. (NSM, LV.)

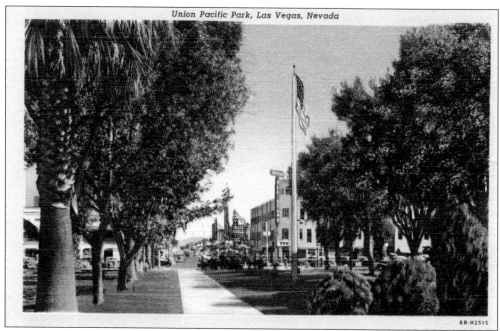

Union Pacific Park, Las Vegas, Nevada

Union Pacific Park was located at the western end of Fremont Street. This beautiful park was in front of the train depot. A popular beanery was part of the depot as well. Locals liked to stroll over to the park in the evening on hot summer days and enjoy the shade. Teenagers drove around the circular drive on Saturday nights as they cruised Fremont Street. The park was demolished in the 1960s.

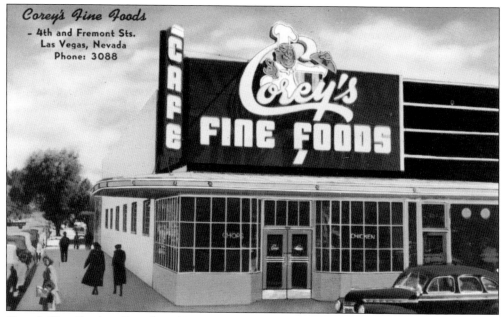

Corey's Fine Foods
- 4th and Fremont Sts.
Las Vegas, Nevada
Phone: 3088

Corey's Fine Foods at Fourth and Fremont Streets was a local teenage hangout. With its great hamburgers and frosty milk shakes, teens from the local high school gathered there after school to see and be seen. Owned and operated by the Coreys, a local family, Corey's went out of business in the 1960s.

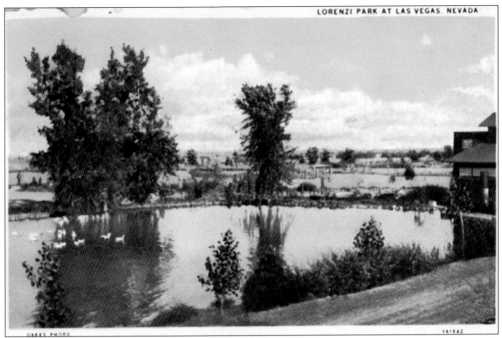

Lorenzi Park was a popular place to escape the heat. Created by local pioneer David Lorenzi, the park offered two man-made lakes filled with fish, a swimming pool with a fountain in the center, and a band shell with a movie screen. Locals could row boats across the lakes while their children swam in the pool. Bands played throughout the summer as young and old danced under the stars. (NSM, LV.)

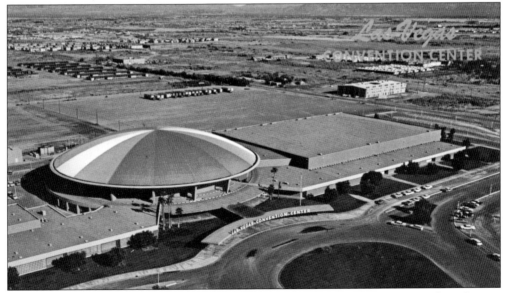

The Las Vegas Convention Center opened on April 29, 1959, with 110,340 square feet of room. U.S. president John F. Kennedy spoke in the Rotunda less than two months before his fateful trip to Dallas. The Beatles performed there in 1964, and Muhammad Ali boxed there in a series of fights for the championship title. The Rotunda, shaped like a flying saucer and trimmed in green neon, was demolished in 1990. (NSM, LV.)

43

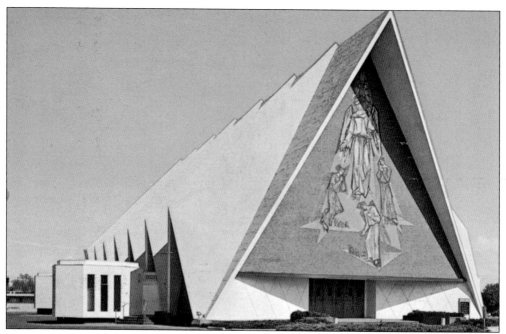

The Guardian Angel Cathedral was opened in 1963. With a beautiful mid-20th-century modern look designed by famed African American architect Paul Revere Williams, the church is located just off the Las Vegas Strip. The church has a series of beautiful stained-glass windows that include a gambling theme. The church was built to accommodate the graveyard-shift workers who were unable to attend the traditional Masses. (NSM, LV.)

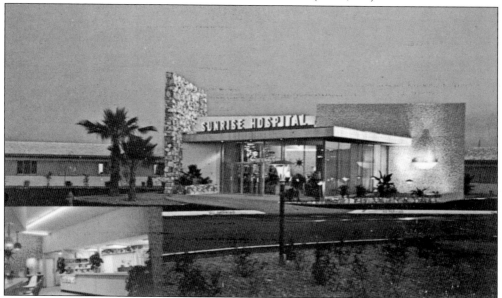

Sunrise Hospital was opened in 1958 and is located near the Las Vegas Strip. Before then, the majority of people with serious illnesses traveled to Los Angeles, California, for quality medical care. It became apparent that Las Vegas needed a modern hospital equipped with the latest technology. A group of investors, including Moe Dalitz, helped to finance the building of the hospital to meet the growing needs of the community. (NSM, LV.)

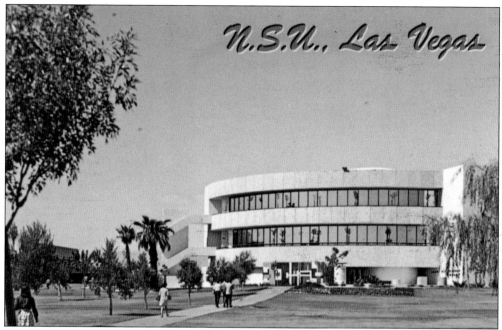

This is an early view of the University of Nevada, Las Vegas (UNLV) when it was called Nevada Southern University. The university was officially founded in 1957, and the first classes were held in Maude Frazier Hall. The graduating class of 1964 had 29 students in its first commencement program. In 1968, Nevada Southern was given equal status with its former parent institute in Reno and became UNLV. (NSM, LV.)

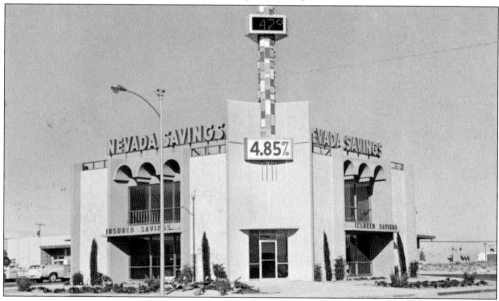

As Las Vegas continued to grow, the boundaries of the town began to expand. Many new family homes were being built west of downtown, and families were moving into neighborhoods like Hyde Park, Charleston Heights, and Westleigh. As the neighborhoods grew, so did the need for schools, banks, and retail stores. The Nevada Savings Bank opened a branch on West Charleston Boulevard to accommodate the new neighborhoods. (NSM, LV.)

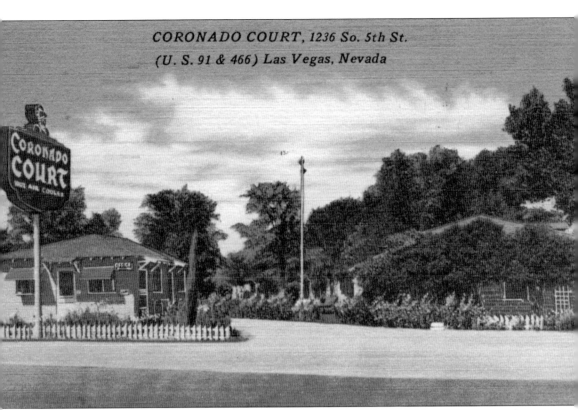

CORONADO COURT, 1236 So. 5th St.
(U. S. 91 & 466) Las Vegas, Nevada

The Coronado Court was built in the 1940s at 1236 South Fifth Street. The court had 10 cabins with two units per cabin. The well-kept grounds were lush with grass, trees, and flowers. The court was later called the Good Luck Motel. A trailer park was added to the south end of the property in the 1950s.

Four

MOTELS

From the beginning, Las Vegas was a prized stop on the journey from Los Angeles, California, to Salt Lake City, Utah. An abundance of underground wells and natural springs had made it attractive to Senator Clark when he was building the San Pedro, Los Angeles, and Salt Lake Railroad. Clark saw Las Vegas as a vital water stop along the train route.

Automobile travelers did, as well. In those days before interstate highways and freeways, travel was not nearly as easy as it is today. Back then, crossing the desert was more of a harrowing adventure, done in cars laden down with radiator bags and no air-conditioning.

Highway 91 (or the road from Los Angeles, California, as it was commonly called) cut across Southern Nevada in a south-to-north trajectory. Once it crossed Fremont Street, it became the Arrowhead Highway (or the road to Salt Lake City, Utah). The other way to get to Las Vegas was across Route 66, the "Mother Road," to Kingman, Arizona, where one would turn right and head north. Crossing over the Hoover Dam, one would drop down to Boulder Highway and cut across the desert floor to Fremont Street.

There was not an easy way to get to Las Vegas then; nevertheless, travelers still braved the heat and the wind to arrive at their destination. To accommodate those hearty souls, small motels quickly sprang up. On the far end of Fremont Street, where it meets Boulder Highway, blocks of small auto-court motels were built with themes from everything from Swiss chalets (probably to invoke that false sense of cool mountain air) to Western-style lodgings. Almost all had swimming pools placed strategically within eyesight of tired drivers, beckoning them to come in out of the heat and relax.

Since this was Las Vegas, of course, beautiful neon signs were used to lure tourists. In those pre–urban sprawl days, the neon signs could be seen miles away in the nighttime skies.

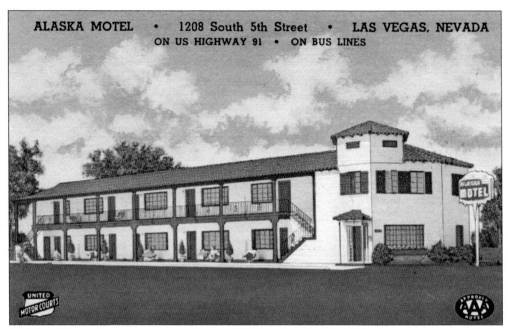

This Spanish-style, two-story motel opened for business in 1947. The faux snow–covered sign was downed with neon-detailed icicles. The hotel had hardwood floors and wrought-iron accents, including door handles and lighting fixtures. While most of the motels in Las Vegas had swimming pools, the Alaska did not. The motel became a youth hostel in the 1980s and is still open today.

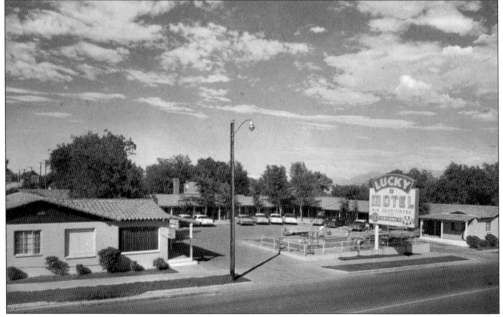

The ranch-style Lucky Motel was built in 1951 at 1111 East Fremont Street within walking distance to theaters, shopping centers, casinos, and restaurants. The motel gave out small, colorful, plastic slot machines with the motel's name on the bottom. With only 28 units, it did not take long to fill the motel.

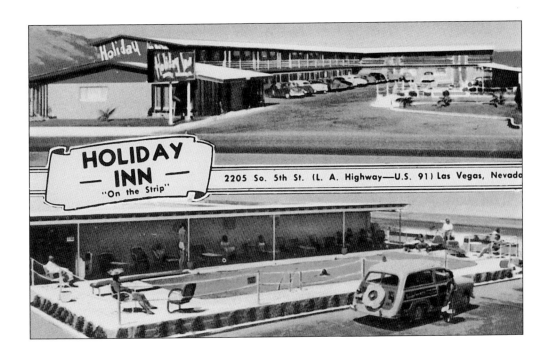

The Holiday Inn Motel opened in 1952. In the 1960s, the motel was forced to change its name by the Holiday Inn motel chain. They agreed to modify it to the Holiday Motel and installed a new sign. It was similar to the Holiday Inn chain signs in shape and size, and it is a great example of roadside signage. With its tinker-toy, Sputnik-like look, it gives a feeling of fun in the sun. It is one of the most photographed signs in Las Vegas. (NSM, LV.)

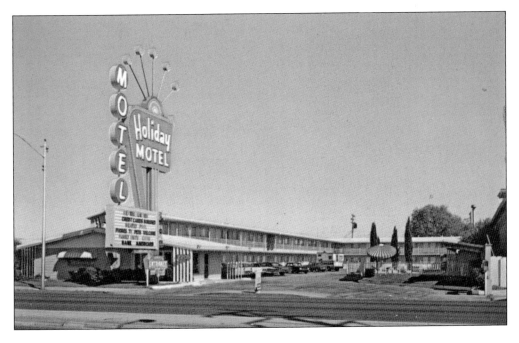

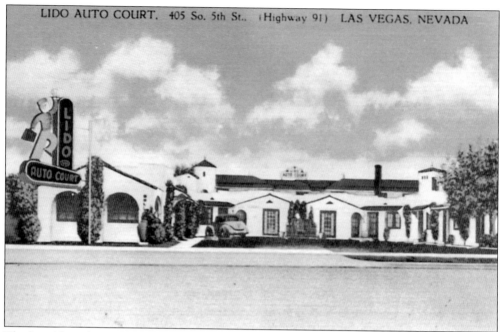

LIDO AUTO COURT. 405 So. 5th St., (Highway 91) LAS VEGAS, NEVADA

The Spanish-style Lido Auto Court was built in the 1930s at 405 South Fifth Street. The colorful neon sign depicted a bellboy holding a pitcher on a tray in one hand and a suitcase in the other. In the 1950s, the Lido dropped the term "auto court" and added "motel" to their sign.

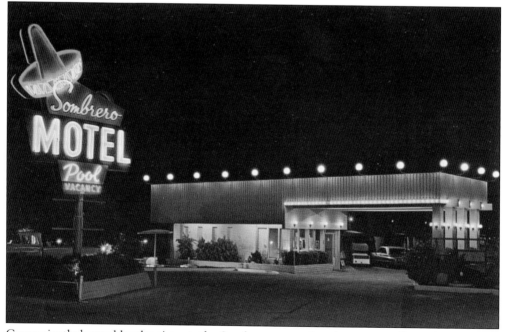

Conveniently located by the airport, the Sombrero was a favorite among pilots who wanted a quiet place to rest. The motel had a deck atop the carport and picnic tables on the front lawn. In the 1970s, the name of the motel was changed to the Pollyanna Motel. It was demolished in 2005.

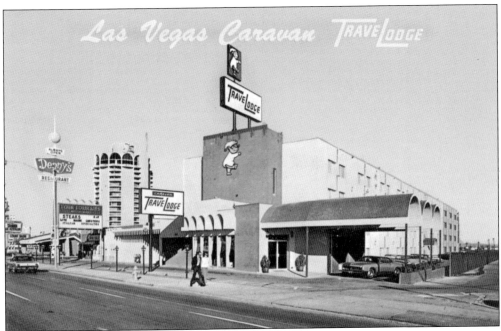

The Caravan TraveLodge was located at 3419 Las Vegas Boulevard South. The hotel had 161 rooms and was located in the heart of the Las Vegas Strip next to the famous Sands Hotel and Casino. The Four Fountains Restaurant and Bar was next door. The TraveLodge was eventually taken over by the Casino Royale and is still used today.

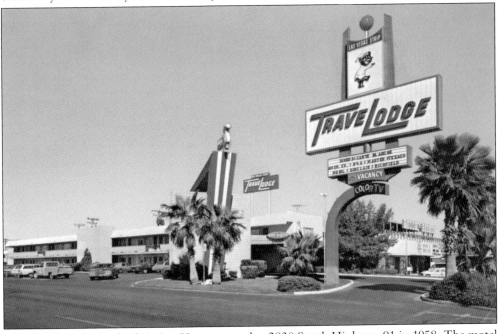

The first TraveLodge built in Las Vegas opened at 2830 South Highway 91 in 1958. The motel had 99 rooms, and the rates varied from $8 to $14. The entrance had a long porte cochere that connected to a curved pylon sign. The motel was in the heart of the Las Vegas Strip across the street from the Riviera Hotel and Casino.

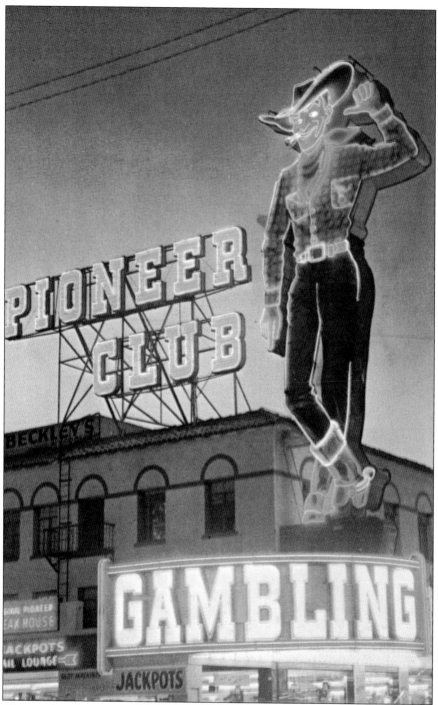

Vegas Vic was the idea of the chamber of commerce. It approached YESCO about building a neon cowboy. He was 75 feet tall and had one moveable arm. He proclaimed "Howdy Pardner!" every 15 minutes. In the mid–1990s, Vic was lowered to fit under the new canopy. His arm no longer moves, and he has not talked in more than 40 years. But he remains an iconic symbol of Las Vegas.

Five

ROADSIDE ARCHITECTURE

Perhaps no other city embraced the automobile like Las Vegas did. In an era of optimism, excitement, and can-do spirit, America was on the go, and the automobile was the preferred method of transportation.

Unlike urban cities back east, Las Vegas was expansive in those days. Surrounded by harsh terrain on all sides, Las Vegas beckoned the motorist to pull off the highway and into an air-conditioned oasis of unparalleled splendor. With its low-slung, ranch-style resorts, Las Vegas took to roadside architecture unlike any other city had before. Where other cities considered neon cheap and tawdry, Las Vegas reveled in it. Brightly colored, flashing signs lit up the darkened highways and could be seen from far in the distance, a beacon to the weary traveler.

From the neon windmill atop the original El Rancho Vegas to the entire neon galaxy that exploded in vibrant color across the front of the Stardust Hotel, the signage became as big an attraction as the resorts and entertainment they publicized. The Dunes sign was, for a brief time, the tallest sign west of the Mississippi—that is until the Stardust redid their original Saturn-inspired sign and created the newest, tallest sign.

Every night was an amazing light show of animated signage scattered across the desert floor. From Betty Willis's iconic "Welcome to Las Vegas" sign on the south end of the Las Vegas Strip, to the neon canyon of Glitter Gulch, to the auto court fantasy signs of East Fremont Street, neon was king. Neon designers like Hermon Boernge, Kermit Wayne, Jack Larsen, and Brian "Buzz" Leming all worked together in designing some of the most innovative and beloved neon signs of their day.

It is an era that has, sadly, passed into history. While some of the signs remain, thanks in part to the Neon Museum, many have been lost. The images here remind one of the innovation and imagination that created magic across the desert floor of Las Vegas.

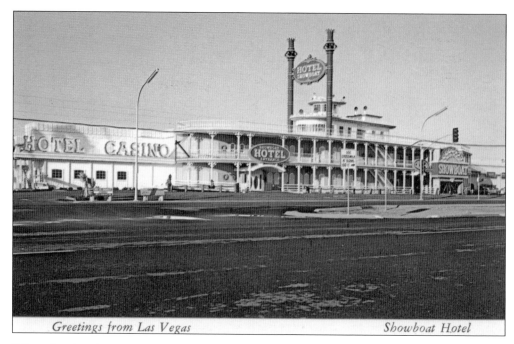

Greetings from Las Vegas *Showboat Hotel*

When the Showboat Hotel and Casino opened in 1954, it was considered by most to be the first locals' casino. Cheap food, great entertainment, and loose slots were a big draw for customers. The Showboat was surrounded by desert. Boulder Highway, the main thoroughfare from the Hoover Dam, went right by the hotel. Hotel guests could lounge by the pool, which was located in the front of the property facing the highway. Weary travelers would often stop just because of the pool. There was also a bowling alley in the back where professional tournaments were held. At night, the neon paddle wheel riverboat could be seen from 8 miles away in Henderson.

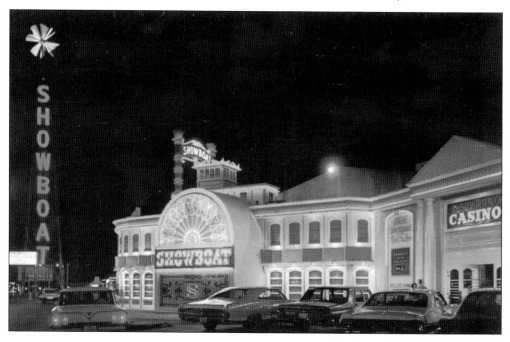

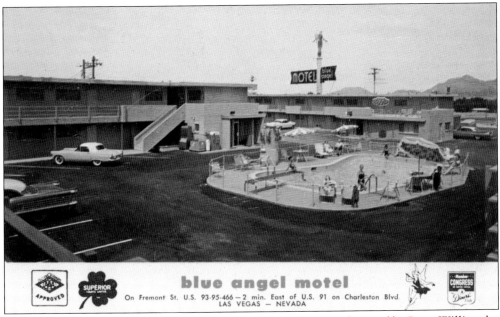

The Blue Angel Motel opened in 1956. The well-known sign was designed by Betty Willis, who also designed the world-famous "Welcome to Fabulous Las Vegas" sign. Willis was criticized for depicting the well-endowed angel that now overlooks the motel. At one time, the angel revolved and was surrounded by blue jays. Adjacent to the motel were the Blue Onion Drive-In restaurant, a popular teen hangout, and a drugstore.

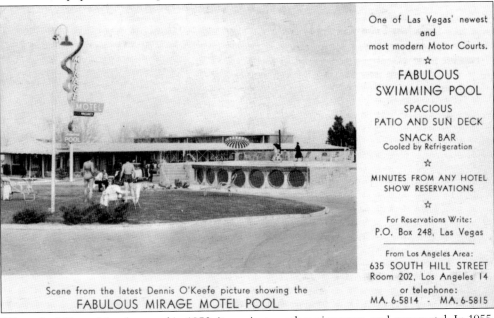

One of Las Vegas' newest
and
most modern Motor Courts.

☆

FABULOUS
SWIMMING POOL

SPACIOUS
PATIO AND SUN DECK

SNACK BAR
Cooled by Refrigeration

☆

MINUTES FROM ANY HOTEL
SHOW RESERVATIONS

☆

For Reservations Write:
P.O. Box 248, Las Vegas

From Los Angeles Area:
635 SOUTH HILL STREET
Room 202, Los Angeles 14
or telephone:
MA. 6-5814 · MA. 6-5815

Scene from the latest Dennis O'Keefe picture showing the
FABULOUS MIRAGE MOTEL POOL

When the Mirage Motel opened in 1953, it was just another nice mom-and-pop motel. In 1955, Allen and Susie Rosoff decided to build a swimming pool that would make the place stand out. Visitors driving down Highway 91 were mesmerized by the 9-foot-deep, aboveground swimming pool. The pool had seven porthole windows that measured 4 feet in diameter. The motel was destroyed in 2005.

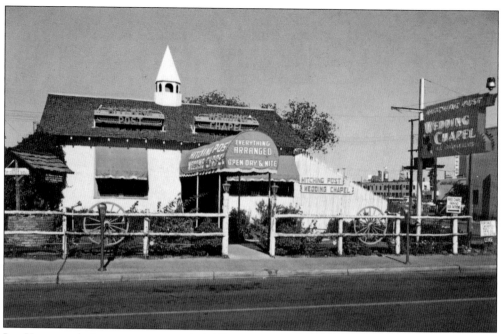

Las Vegas made it easy to get married. There was no blood test required or waiting period. Many a couple eloped to Las Vegas. In 1923, the residence at 226 South Fifth Street was built. After remodeling the home, Halley and Mildred Stewart opened the old West–themed Hitching Post Wedding Chapel in 1940. It was one of the first wedding chapels in Las Vegas. Today a bank sits on the property.

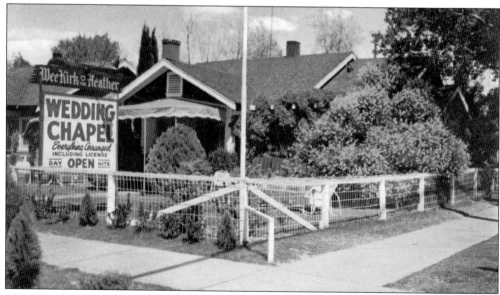

The Wee Kirk O' the Heather was built in 1925 as a residence. In 1940, the home was transformed into a wedding chapel, and it was the second wedding chapel to open in Las Vegas. By the early 1950s, nearly 20,000 people were getting married in the chapel. After more than 65 years, the chapel is still a popular place for people to wed.

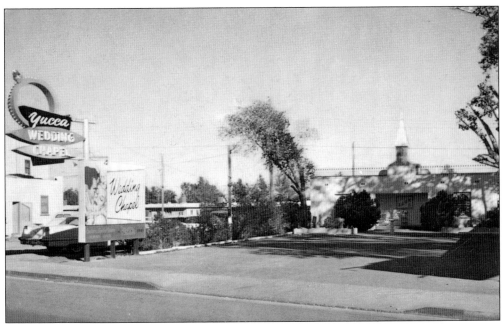

In the 1950s, Las Vegas was becoming a major tourist destination. While many people came to gamble, others wanted to get married. Like most wedding chapels, the Yucca Wedding Chapel offered people a wedding package at a more reasonable cost than at-home weddings. Since Las Vegas had cheap accommodations, food, and entertainment, it was the ideal place to honeymoon. The giant ring on the sign left no doubt that it was a wedding chapel.

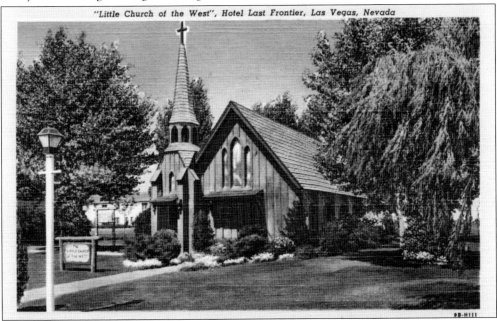

"Little Church of the West", Hotel Last Frontier, Las Vegas, Nevada

The Little Church of the West was originally located next to the Hotel Last Frontier. In 1954, when the Frontier was remodeled, the church was moved from the north side of the hotel to the south side. In 1979, it was moved farther south to the Hacienda Hotel. In 1996, when the Hacienda was imploded, the church was moved to its current location south of Mandalay Bay.

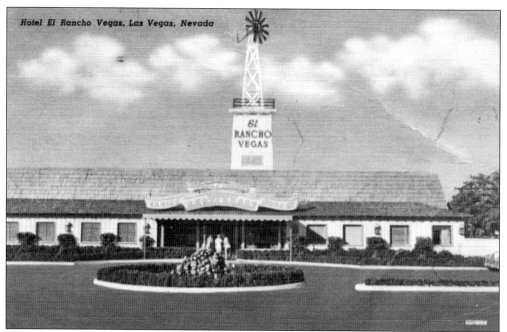

"Stop at the Sign of the Windmill" was the logo of the El Rancho Vegas, the first resort on what would become the Las Vegas Strip. Highway 91 from Los Angeles ran right by the hotel, and at night, drivers could see the neon windmill for miles before they ever reached the hotel. It was a beacon in the night inviting them to come in and relax.

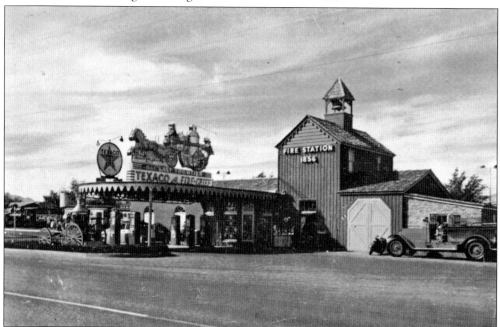

The Hotel Last Frontier opened a year after the El Rancho Vegas. It recalled the Wild West in its decor. As part of that theme, it had the Last Frontier Village next door. This is a Texaco gas station housed in a replica of a c. 1856 Western firehouse. In those days, gas stations were full-service and a necessity when driving across the desert, especially in the summer.

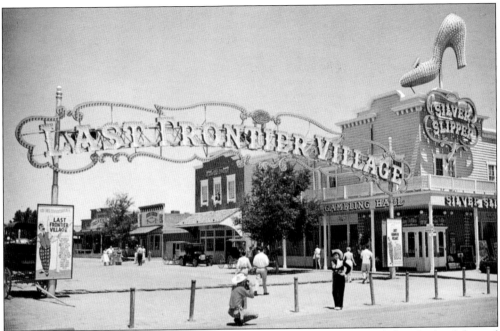

The Last Frontier Village was part of the Hotel Last Frontier. It appealed to both adults and children with its mix of authentic Western buildings, shops, and antiques. Stagecoach rides, shoot-outs, and the Silver Slipper Saloon and Gambling Hall provided entertainment. The giant silver slipper that sat atop the building revolved and shone brightly down the highway at night.

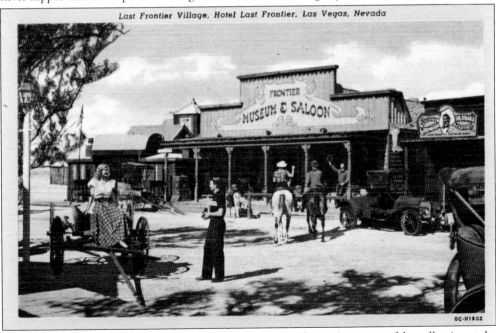

The Last Frontier Village boasted an authentic Chinese Joss house (now part of the collection at the Nevada State Museum, Las Vegas) and a museum filled with items from an earlier era. The village was nationally known for its collection of antique guns. But most of all, the village offered children something fun to do amidst the adult playground that the Las Vegas Strip was becoming.

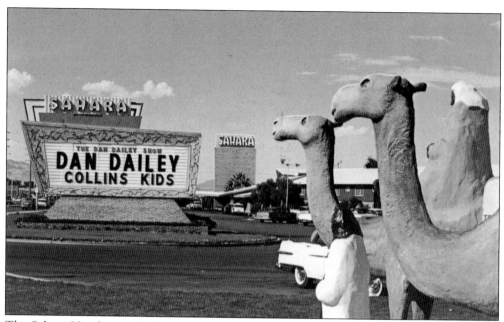

The Sahara Hotel opened in 1952 with a Moroccan theme. From the interior with names like the Casbar and the Congo Room to the landscaping outside, everything was designed to evoke an exotic setting. These giant camels, accompanied by a couple of nomads, stood outside the hotel for almost 40 years before they were taken away in an attempt to give the hotel an updated look.

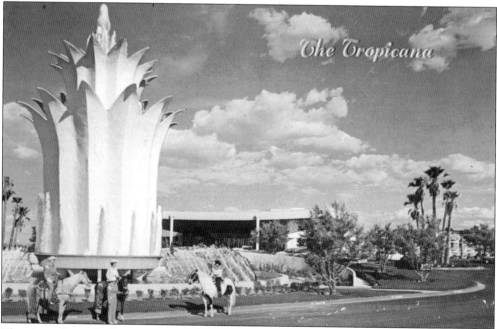

The giant pineapple fountain in front of the Tropicana Hotel on the south end of the Las Vegas Strip evoked a feeling of Miami Beach and the famed Fontainebleau Hotel. The fountain was 60 feet high, and its cascading water was part of the hotel's refrigeration system. At night, the fountain was bathed in blue- and rose-colored light and was trimmed in animated neon.

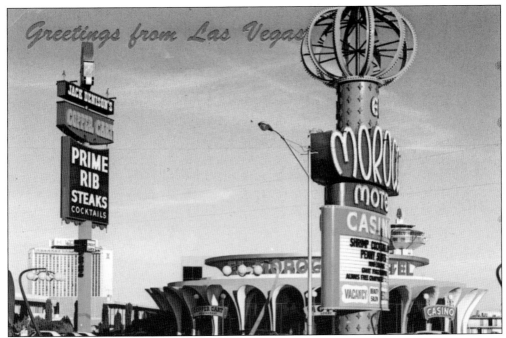

The El Morroco Motel was also on the Las Vegas Strip. It opened in 1964. The Bank of Las Vegas had a branch inside the main building next to the lobby. The bank branch was later replaced by a casino. Jack Denison's Copper Cart restaurant was a favorite eatery and was known for its prime rib. The El Morocco was torn down in the spring of 2008.

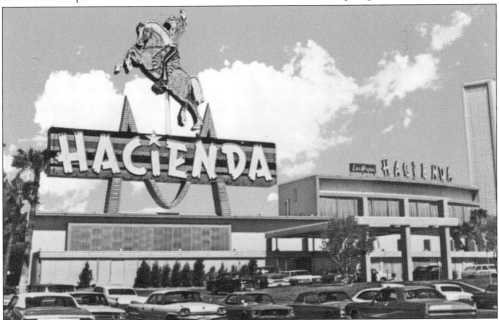

The Hacienda Horse and Rider rode above the Hacienda Hotel on the south end of the Las Vegas Strip. The horse was patterned after owner Judy Bailey's prized possession. A smaller version of this sign was just outside McCarran Airport and helped advertise the hotel to arriving tourists. That sign has been restored and is now part of the Neon Museum in downtown Las Vegas.

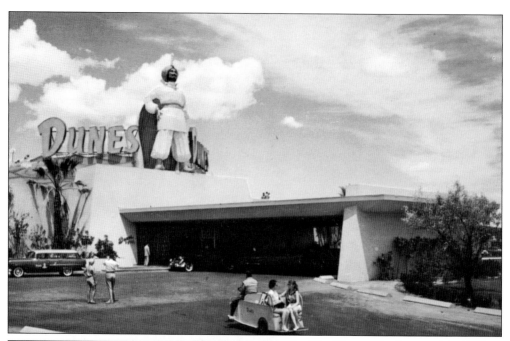

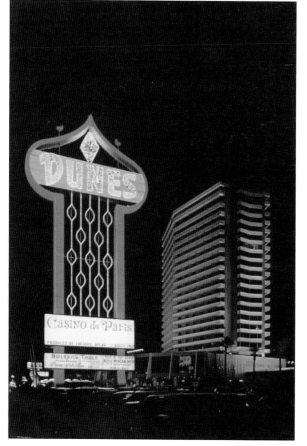

The Dunes Hotel opened in 1955 with a giant fiberglass sultan rising 35 feet in the air. His outfit included a diamond-studded turban that was actually a car headlight that had been gem-cut. When the hotel was remodeled a few years later, he was moved to the west end of the golf course, where he could be seen greeting drivers passing on I-15.

In 1964, one of the icons of the Las Vegas Strip was introduced. The 180-foot-tall sign shot neon into the heavens, and the flicker bulbs lit up the word "Dunes." The sign's foundation was 80 feet wide. The onion dome paid homage not only to the Arabian nights but also to the spade playing card as well. It was, for a few years, the tallest freestanding neon sign in the world.

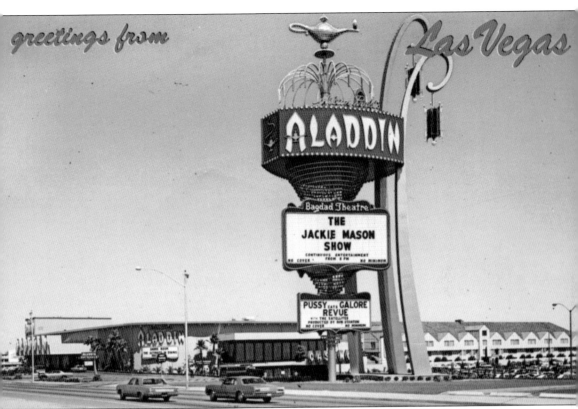

The Aladdin Hotel's iconic sign had Aladdin's lamp at the top. It was designed by YESCO's Jack Larsen. It was a sign that pushed the boundaries of design and quickly became an icon of roadside architecture. It cost $750,000 (in 1966 dollars) to design and fabricate. The sign was demolished in 1974. Aladdin's lamp was saved and is part of the Neon Museum.

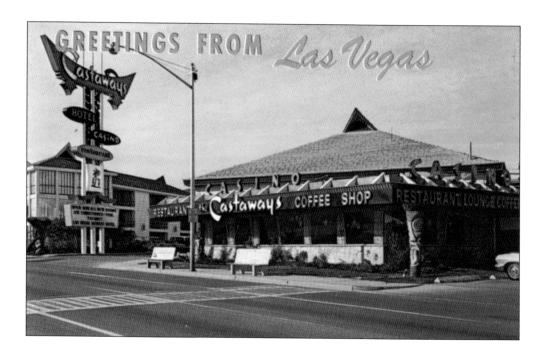

The Castaways Hotel and the Gateway to Luck brought Polynesia to Las Vegas. This historic East Indian temple symbol, hand carved out of teakwood, weighed 14 tons and was 35 feet tall. The Polynesian-themed Castaways Hotel and Casino was formerly the site of the Red Rooster Nite Club and the Sans Souci Auto Court. It was torn down in the 1980s to make room for the Mirage Hotel and Treasure Island. (NSM, LV.)

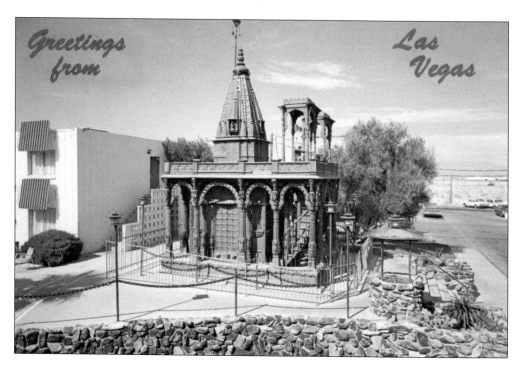

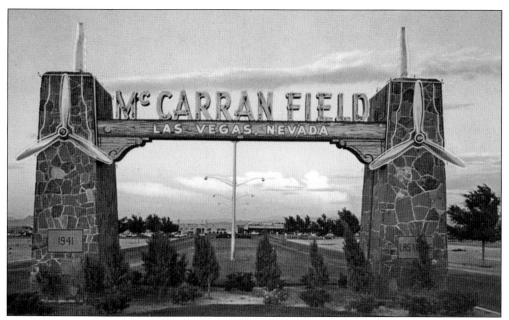

This image shows the entrance to McCarran Field, which still stands today on the east side of Las Vegas Boulevard at the far end of the Las Vegas Strip. With its neon propellers and rustic Western lettering, it is a reminder of the days when Las Vegas was a much smaller town. Today the airport is one of the busiest in the world. This entrance is now used for private airplane owners.

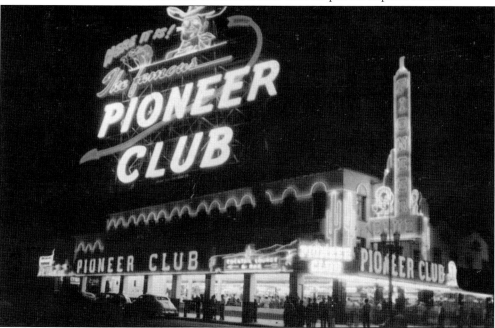

The Pioneer Club neon sign is pictured here sans Vegas Vic. Before the chamber of commerce commissioned Vegas Vic, a similar visage was used in print advertising. While Vic was under construction, this rooftop sign was installed to let everyone know where the famous Pioneer Club was. The thumb moved back and forth in an animated pattern just in case someone might miss where to turn for the free parking.

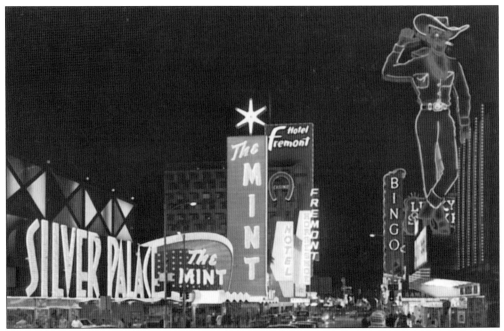

Glitter Gulch is shown here in the early 1960s. With their mammoth pylon neon signs and 75-foot-tall Vegas Vic towering over the people below, the signs took on a life of their own. Animated neon and chasing flicker bulbs lit up the nighttime sky and could be seen for miles in any direction.

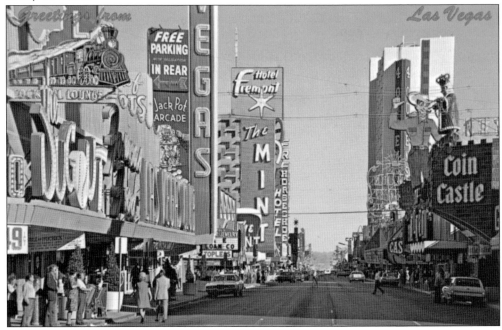

Glitter Gulch during the day does not have quite the same look as it does at night. However, during the day, it is more apparent, perhaps, where each property begins and ends because one's attention is not drawn to the neon lights. Today many of the signs have been replaced with modern facades, but Vic, even under the canopy, still towers above the street.

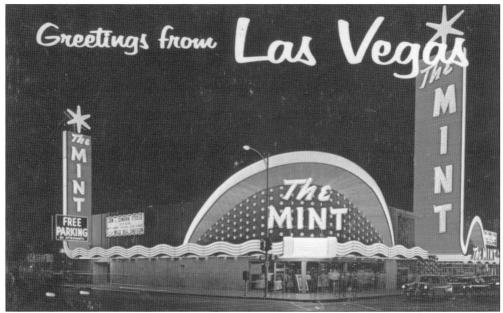

The Mint is probably the most beloved lost signage on Fremont Street. With its pink-and-white animated wave of light over the entrance and its matching "eyebrow" on the corner, the Mint signage was filled with the exuberance and optimism of the era. It was one of the first signs to exploit the three-dimensional sweep of neon. It was designed by YESCO's Kermit Wayne and Hermon Boernge.

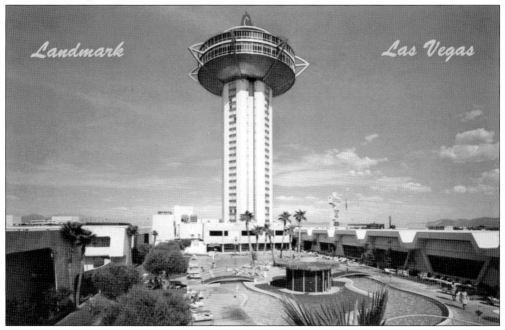

The Landmark Hotel was located off the strip across the street from the convention center. It was patterned after the Seattle Space Needle and added a futuristic touch to the flying saucer–shaped rotunda of the convention center across the street. At the top of the building was a bar and lounge that offered spectacular views of the city below.

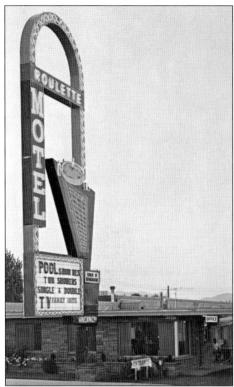

In the 1950s, neon signs were everywhere in every shape and size. Casinos, restaurants, shopping centers, and motels all had neon signs. A perfect example is the sign in front of the Roulette Motel. The Roulette opened in 1955 and had a large neon roulette table on the sign. The motel itself was tastefully covered in flagstone with a neon lit fascia board.

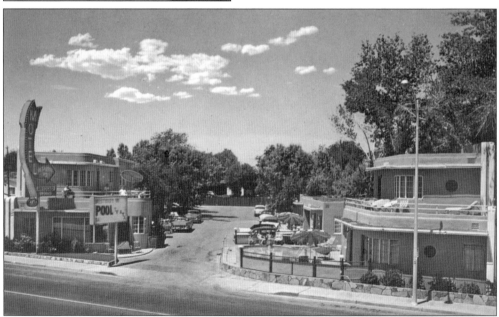

In 1940, the Westward Ho! Motel opened at 1106 South Fifth Street. The Streamline Moderne–style motel was owned and operated by Steve Mitchell Sr. With its sweeping arrow pointing to the entrance, and the pool and sunbathers visible from the highway, the Westward Ho! offered a cool respite from the summer heat of traveling. This property is not related to the Westward Ho Motel and Casino.

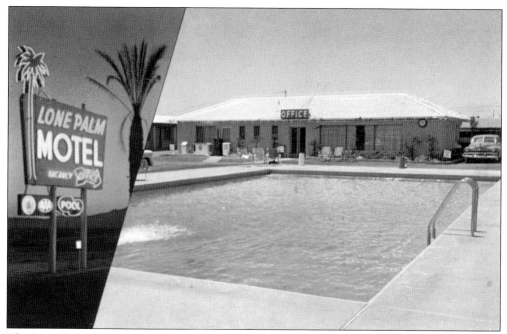

The Lone Palm Motel and trailer park was located on Highway 91 just north of Bond Road (later named Tropicana Boulevard). Senior citizens enjoyed staying at the tree-lined trailer park on the motel property. The Lone Palm had 31 units, laundry facilities, a large swimming pool, and a radio in every room.

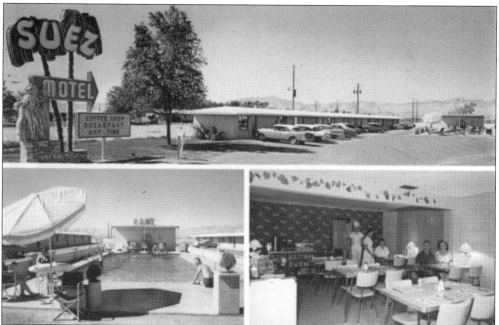

Many of the motels in Las Vegas used creative neon signs to draw customers in. The Suez Motel was no exception. Beneath two neon palm trees, a neon belly dancer greeted motel guests. The animated neon sign could be seen from miles away. Among the motel's amenities were a large pool and a coffee shop.

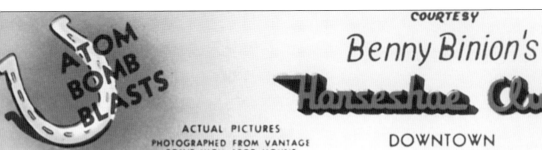

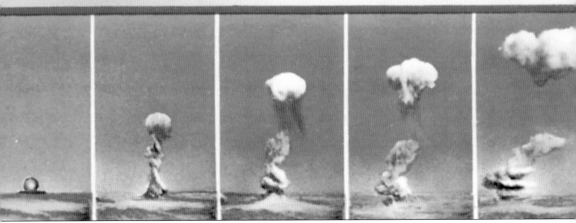

In the early 1950s, nuclear testing came to Nevada. Aboveground blasts could be seen from various vantage points around the valley. Hotels like the Horseshoe Club and others advertised the testing as reason to visit Las Vegas. Atomic cocktails, hairdos, and atomic blast–watching parties were all the rage for a few years. This postcard reminds one of an era when the potential threat of fallout was still an unknown. (NSM, LV.)

Six

POSTWAR

Like the rest of the country, Las Vegas had been a part of the war effort during World War II. The military had established a gunnery school. In order for the military to establish a base in Las Vegas, the red-light district—Block 16—had to be permanently shut down. Out in nearby Henderson, the Basic Magnesium plant had helped supply important materials for the war effort. Young men had enlisted and gone off to war while their wives, sisters, and mothers held down the home front and did their part by planting victory gardens and rationing.

As the war wound down, Maxwell Kelch, the owner of the local radio station KENO and head of the chamber of commerce, realized that Americans would want to travel once the war was over. He helped establish the Desert Sea News Bureau to publicize Las Vegas as a tourist destination.

Back then the majority of mail addressed to Las Vegas was often routed to the better-known Las Vegas, New Mexico. The men of the news bureau took their jobs seriously. The creation of the news bureau coincided with the rise of the Las Vegas Strip, as Highway 91 was becoming known as.

Since the first resort on the Las Vegas Strip, the El Rancho Vegas, had opened in 1941, more and more visionary dreamers were betting on Las Vegas. The fact that gambling was legal in the small town made it a lure not only for high rollers, but also for the average guys who had gotten a taste of betting and gambling during the war. The photographers of the news bureau seized the opportunity to photograph young couples sitting poolside or out on the town. Those photographs were, in turn, sent to the couple's hometown newspaper where they were run usually on the front page. These "hometown runs," as they were known, made Las Vegas look exciting and affordable to a public eager to throw off the years of skimping and saving and go have a good time.

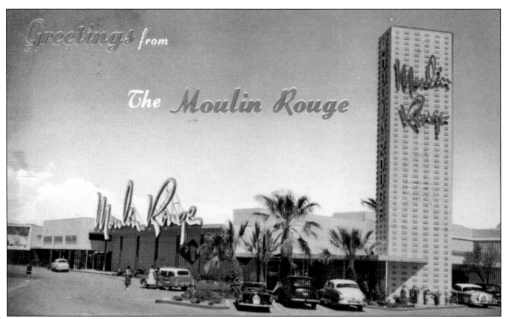

The Moulin Rouge opened in 1955 not on the Las Vegas Strip but in the segregated part of town known as the Westside. It was the first integrated hotel casino in Las Vegas and perhaps the nation. With a chorus line from the famed Cotton Club and a terrific entertainment lineup, the Moulin Rouge had no color barrier, and everyone was welcome. It closed under mysterious circumstances less than six months later.

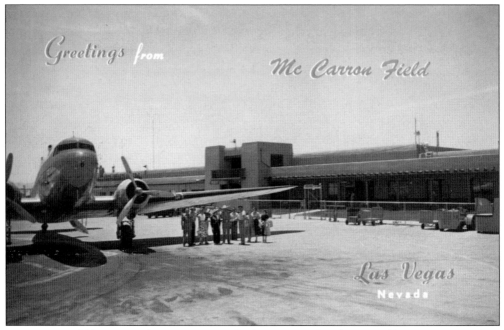

McCarran Field began as Alamo Airways, which was owned and operated by George Crockett and his wife, Peg, in 1942. In 1948, the airport was purchased by Clark County, and a new airport was opened in 1949. The small airport was named after Nevada senator Pat McCarran, who had been influential in developing aviation travel nationwide. (NSM, LV.)

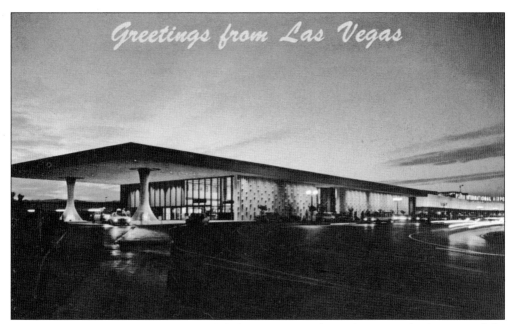

As Las Vegas continued to grow, so did the airport. In the early 1960s, the location of the entrance and the terminals was moved from their Las Vegas Strip location to Paradise Road. A new facility was commissioned. Architect Welton Becket, using inspiration from the recently opened TWA terminal at JFK International Airport, created a futuristic airport terminal that opened in March 1963.

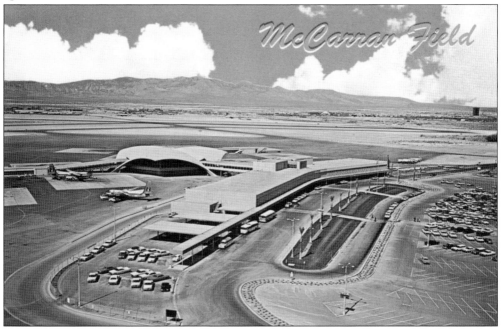

Not long after opening the new terminal, air travel to Las Vegas continued to increase because the city was being promoted as the new adult playground. A new terminal was built at a cost of $5 million. The rounded dome of the main terminal is still in use today, though airport expansion has made it almost unrecognizable.

With the end of World War II and years of sacrifice and rationing, drive-in restaurants became popular in Las Vegas, especially with teenagers. Local high school students could now borrow the family car, fill up the gas tank, go cruise Fremont Street, and, when they got hungry, meet their friends at a local drive-in like Sill's or the Round-Up. Both were located only blocks from one another, and both offered carhop service. Teenagers would grab a quick burger, fries, and a Coke before heading back to cruise up and down Fremont Street, honking at their friends and displaying their school colors for locals and tourists alike.

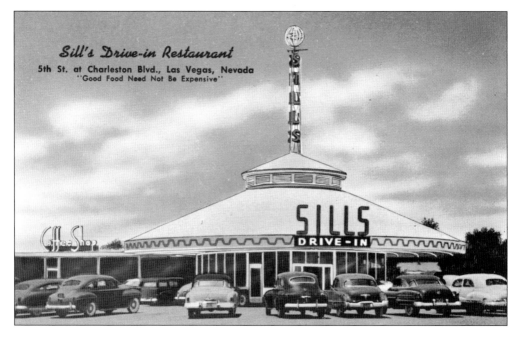

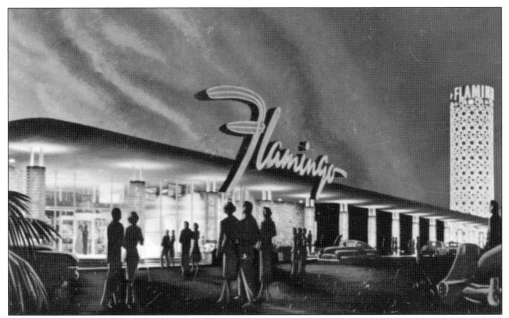

When the Flamingo Hotel opened on the Las Vegas Strip, it ushered in a new era. Abandoning the traditional Western motif, the design of the Flamingo Hotel was quite unlike anything locals had seen before. In 1953, the Flamingo underwent renovations. The entrance was made more pedestrian friendly, and the giant neon lettering across the front of the building let everyone know that they were at the fabulous Flamingo.

The design of the Sands Hotel was completely mid-20th-century modern. Designed by famed architect Wayne McAllister, the hotel resides in the collective memory as the epitome of cool. Atop the porte cochere were three sharp-edged beams that jutted out from the building and flowed over the glass-walled entry, giving the appearance of fins. The two-story, glass-walled entrance was bordered by a wall of marble.

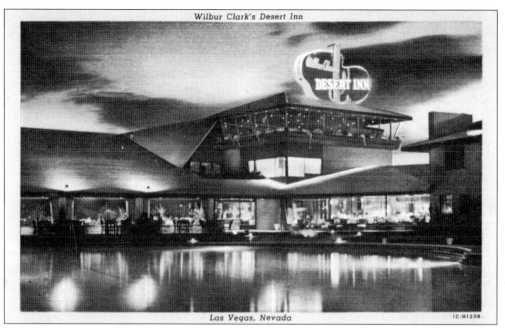

Wilbur Clark's Desert Inn

Las Vegas, Nevada

The Desert Inn was originally designed by Wayne McAllister. The mid-20th-century modern look of clean, crisp lines worked well with pink-hued native stone that was used throughout the property. The famous Sky Room cocktail lounge, perched atop the hotel, offered guests a grand view of the surrounding valley. There was entertainment all night long. Guests felt as though they were floating in the sky.

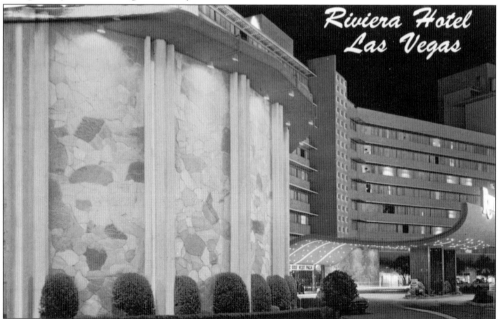

Riviera Hotel
Las Vegas

The Riviera Hotel was the first high-rise hotel on the Las Vegas Strip. The upswept porte cochere and flagstone walls created a warm inviting glow to guests and patrons arriving by car. At nine stories, it was the tallest building on the Las Vegas Strip. The hotel had a lavish grand opening where Liberace, soon to be the highest-paid entertainer on the strip, wowed the crowd.

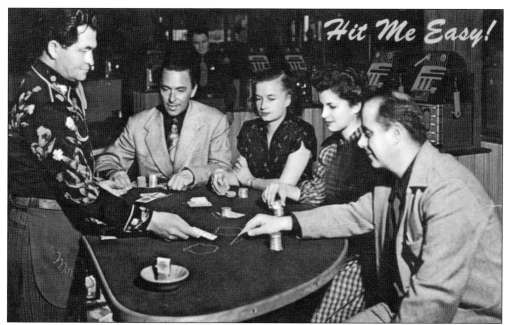

As more people traveled to Las Vegas to enjoy gambling, they also adhered to the dress code of the day, which meant that men wore jackets and ties, and ladies wore dresses and sometimes gloves. The dealer here is dressed in Western wear, including an elaborate embroidered shirt, while the gamblers are chicly dressed in the attire of the day.

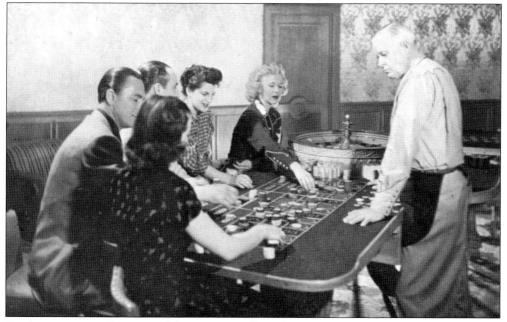

Roulette was a popular game of chance, especially with women. Players placed bets on a number, either black or red. The croupier would spin the wheel in one direction, and the ball would spin in the opposite direction on a tilted circular track around the circumference of the wheel. The ball would finally lose momentum, fall into the wheel, and into one of the numbered slots in either red or black. (NSM, LV.)

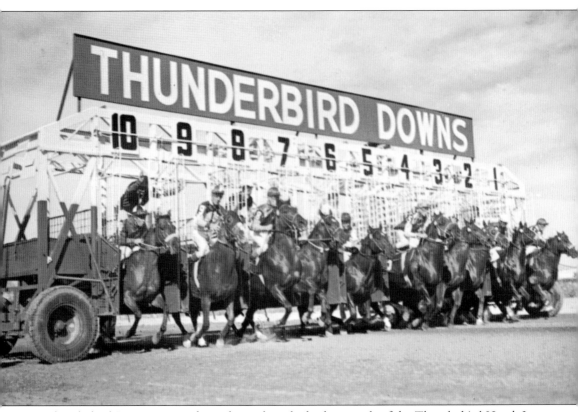

Thunderbird Downs racetrack was located on the back grounds of the Thunderbird Hotel. Joe Wells, the father of Dawn Wells (who played the character Maryanne on *Gillligan's Island*), was instrumental in getting the racetrack off the ground. He was an investor in the Thunderbird Hotel. The five-eighths of a mile racetrack hosted both thoroughbreds and quarter horses. It had pari-mutuel betting and bleachers for those who wanted to watch. Sam Steiger often called the races. Later another track known as Las Vegas Downs opened across Paradise Way. Prior to its closing in the mid-1960s, it was known as the Joe W. Brown Racetrack. Brown had taken over the Horseshoe Club on Fremont Street when owner Benny Binion was sent to prison for tax evasion. He even put his name on the facade of the building while Binion was in jail. Brown sold the property, and the track was razed to make room for the exclusive Las Vegas Country Club. (NSM, LV.)

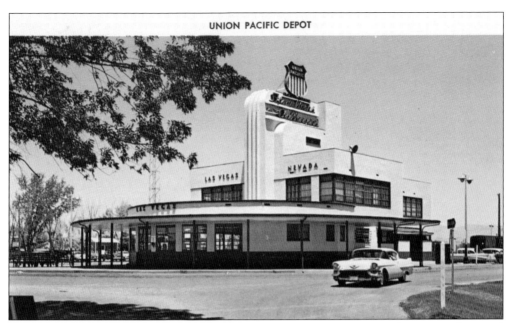

After the war, travelers began visiting Las Vegas regularly. The majority of tourists still arrived by train. To accommodate the new crowds, a new depot was built. This Streamline Moderne–style facility replaced the Spanish Mission–style building that had served the community for 40 years. Air-conditioning and easy access via the circular drive around Union Park made arriving by train an easy and affordable way to travel to Las Vegas.

As highway improvements were made after years of rationing and sacrifice, Americans took to their automobiles to visit the small oasis in the desert they were hearing so much about. Motor court motels had been around for decades. But in the postwar era, they would undergo a transformation to more modern designs meant to invoke the future that lay just beyond the horizon.

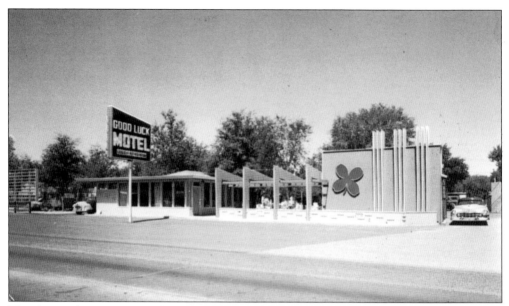

The Coronado Court opened in the 1940s. In 1955, after an extensive remodeling, the motel was given a new name, the Good Luck Motel. A trailer park was added to the south end of the property. A picnic area, a swimming pool, and a shuffleboard court were also added. There was a small game room inside the lobby.

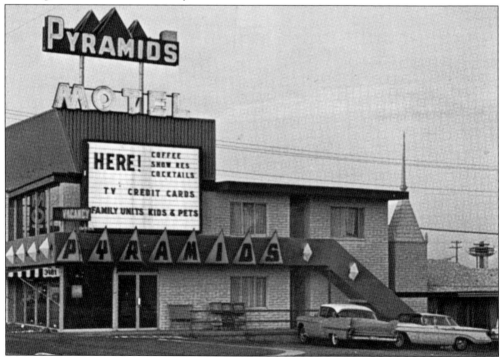

As more casinos were built along Highway 91, motel owners followed. In 1953, the Pyramids Motel was built two blocks south of the Sands Hotel and Casino. In 1971, the property was razed to make way for the River Queen Casino, which later became the Holiday Casino. The Holiday is now part of Harrah's Hotel and Casino.

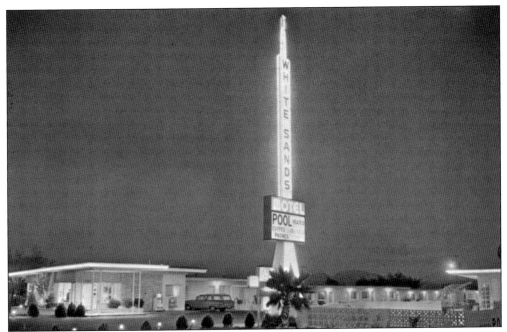

Frank and Margaret Durand moved to Las Vegas from Freehold Township, New Jersey, after selling their business, Durand's Men's Shop. The Durands opened the White Sands Motel at 3889 South Las Vegas Boulevard in 1959. The motel was within walking distance to the Tropicana and Hacienda casinos. Year-round swimming was available in the motel's heated pool.

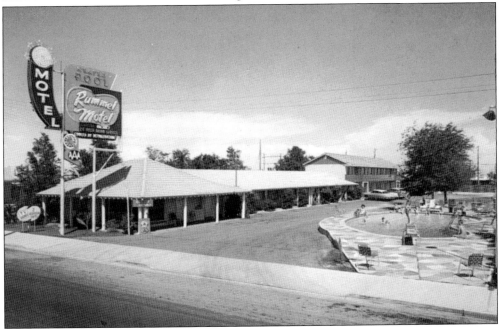

By the 1950s, many motels had been built on Highway 91. To compete with the other properties, the Rummel Motel, built in 1951, offered fun books that could be taken to downtown casinos and used for free meals, nickels, and souvenirs. While staying at the Rummel, guests could swim year-round in the motel's heated pool.

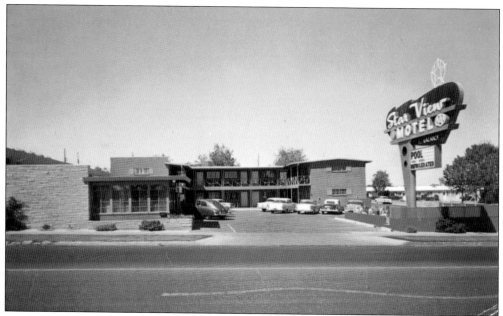

The St. Catherine Motel was built in 1953. The owner thought the name of the motel was too religious and, in 1958, renamed it the Star View Motel. The giant sign was navy blue with red accents and was topped with a freestanding neon star. The motel was modern in style, built with brick and flagstone. The motel office has been completely remodeled, but the building is still in operation.

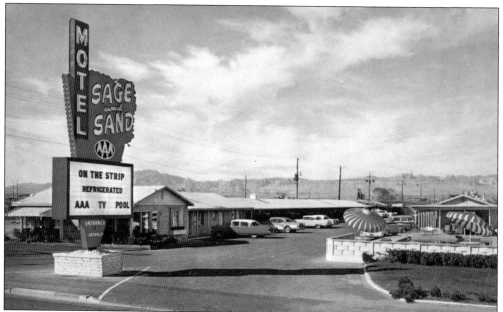

The Sage and Sand Motel was located on Highway 91 across the street from the Flamingo Hotel and Casino. Motel guests could go for horse rides in the desert, swim in the pool, or gamble at nearby casinos. The motel also offered Grand Canyon tours. The motel property was purchased by Caesars Palace in the 1980s and was demolished. The Forum Shops were built on the property.

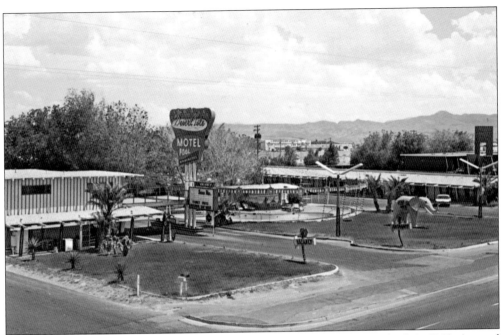

The Desert Isle Motel began its life as a house in the middle of the desert, built in 1940. A motel was added on to the house in the mid-1950s. The motel had two kidney-shaped pools with a slide and neon accents surrounding the deck. Each room was furnished with a coin-operated radio. The pink elephant was added sometime in the 1950s. The motel is still operating.

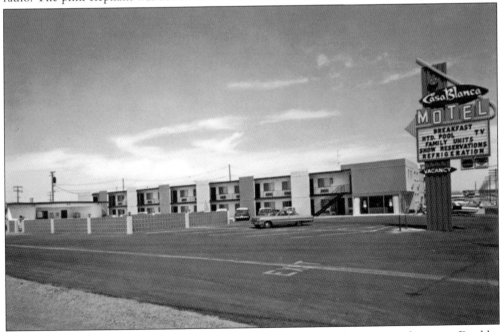

For those who did not want to stay on the Las Vegas Strip or downtown, there was Boulder Highway. The Casa Blanca Motel, located at North Boulder Highway and East Sahara Avenue, was known as a family place. Babysitting services were available. The property was later renamed the Golden City Motel and is no longer standing.

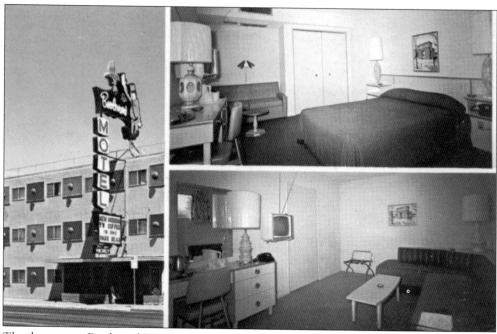

The three-story Boulevard Motel was most recognized for its backlit plastic and neon gendarme and fleur-de-lis. The motel was popular with people staying in town for an extended amount of time because many of the rooms had kitchenettes. It was located close to the downtown area. The motel was demolished in 2005.

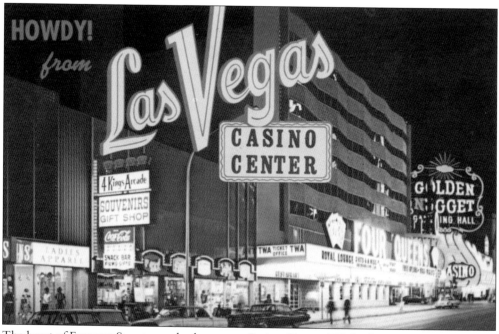

The heart of Fremont Street was also known as Casino Center. While the Four Queens and the Golden Nugget are on the corners, just past the Four Queens is an arcade for kids of all ages, as well as Bain's Ladies Apparel, reminding visitors that the locals shopped in the shadow of the gambling casinos and no one raised an eyebrow.

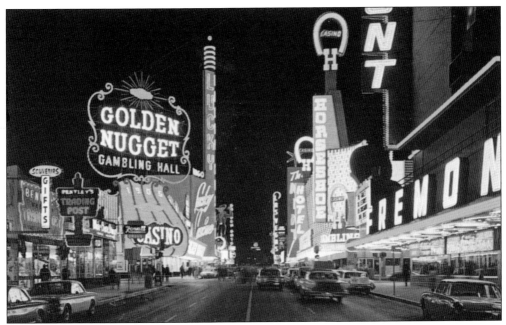

The light of the neon reflects off the cars parked along the street, adding to the feeling that it was never dark in downtown Las Vegas. From neon circles under the Fremont Hotel to the Indian head atop the Hotel Apache sign, Fremont Street is a destination 24 hours a day. At the end of the street, the neon sign for the train depot can be seen.

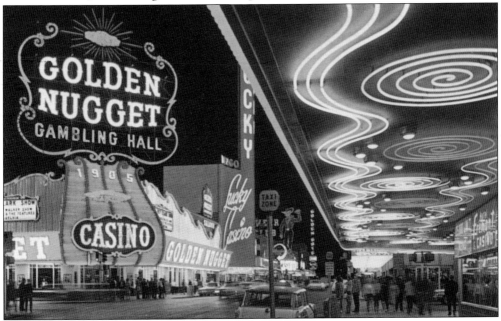

From this angle, the feeling of Glitter Gulch is in the air. Drivers could enter the canyon of neon at Fifth Street and begin the short drive to the train depot and back, all the while being surrounded by these large neon signs on both sides. The signs were huge, towering over the street. From around the valley, Glitter Gulch glowed like a beacon in the empty desert landscape.

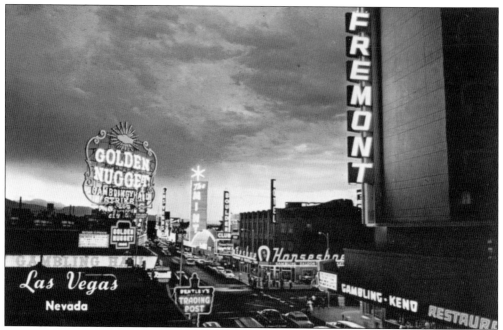

Here is an unusual view of Fremont Street at magic hour as dusk falls and the neon lights come on. The description on the back of the card reminds one that gambling is not only legal in Las Vegas, but it is also the state's greatest industry. Today gaming is still important, but the economy is more diverse.

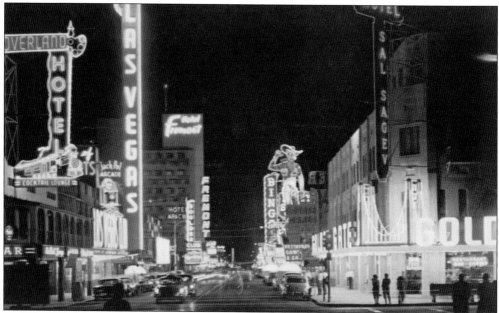

Night falls on Fremont Street in the 1950s. The neon Golden Gate Bridge indicates that the new owners are from San Francisco. On the upper floors, the Sal Sagev Hotel allows gamblers to stay where they play. Across the street, the neon train heralds the Overland Hotel, the second-oldest hotel on Fremont Street. Farther down, the neon Indian head of the Hotel Apache shines out in the night.

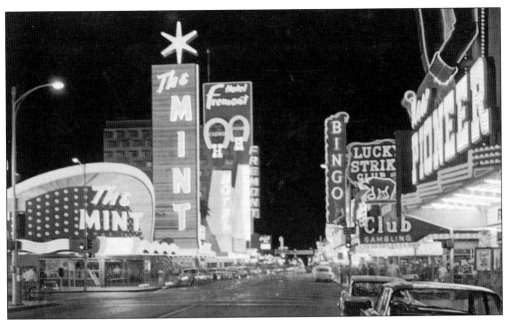

Fremont Street shines brightly at night. The neon cowboy boots of Vegas Vic are in the foreground. The neon bear of the California Club can be seen behind them. A forty-niner is panning gold atop one of the buildings farther down the street. Across the street are the turquoise horseshoes of Binion's Horseshoe Club. The Mint in all its pink-and-white glory anchors the corner in the foreground.

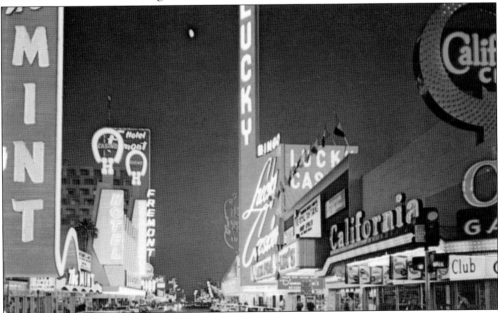

In the foreground is the arrow of the California Club. Rounded arrows like this were popular as advertising in the postwar era. For automobile drivers, they were eye-catching with their frequent animation. The Lucky Casino, with its giant script lettering on the front, is in the background. There is also the neon facade of the Horseshoe Club and a glimpse of the pink-and-white wave over the entrance to the Mint.

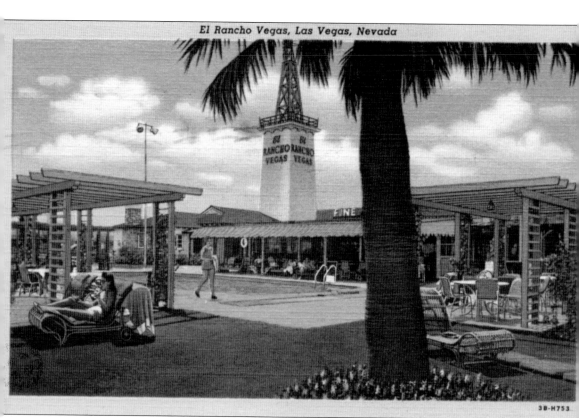

The El Rancho Vegas was the first resort on the Las Vegas Strip. It had a rustic Western motif and opened in 1941. Its neon windmill beckoned travelers from far down the road to stop in, have a leisurely meal, and cool off. The landscaped grounds and cool swimming pool were quite the lure to travelers trapped in hot cars on sweaty summer days.

Seven

LAS VEGAS STRIP

It began quietly enough as the highway to and from Los Angeles, California. The forlorn two-lane blacktop that cut across the desert promised salvation at either end. Where the highway led into Las Vegas, a few entrepreneurial souls began to open small restaurants that included gambling.

In 1940, hotelier Thomas Hull was convinced by local civic booster "Big Jim" Cashman to build a real resort hotel in Las Vegas. The El Rancho Vegas opened in 1941 and catered mainly to the divorcee crowd. With Nevada's new, relaxed divorce laws, women could establish residency in only six weeks and then file for divorce. Women flocked to Reno and Las Vegas when it came time to untie the bonds of wedded bliss.

The Hotel Last Frontier, promising "the early west in modern splendor," soon followed, and then Hollywood publisher Billy Wilkerson began building his own dream resort, the Flamingo, before he fell short of financing and took on Benjamin "Bugsy" Siegel as a financial partner.

Sen. Estes Kefauver and his hearings on gambling and vice turned the heat up on illegal gaming around the country. Since gambling was legal in Las Vegas, gamblers started moving to Las Vegas to build resort hotels catering to the crowds that loved taking a chance on Lady Luck. By the time the 1950s came to a close, there were 12 hotels along the 5-mile stretch of highway now known worldwide as the Las Vegas Strip.

With the top-rated entertainers of the day, such as Frank Sinatra, Dean Martin, and many others, playing nightly in the showrooms, one did not necessarily have to "just gamble" to enjoy a vacation in Las Vegas. What had once been a barren, unforgiving desert was now home to some of the swankiest and most modern hotel resorts in the country.

Additionally, some hotels began adding chorus lines of showgirls that seemed to catch the public's imagination. When Donn Arden imported the Lido de Paris show from Paris, along with many of its original French dancers, for the Stardust Hotel, a new era in showroom entertainment was born.

The beautiful, statuesque, feathered showgirl became an enduring iconic symbol of the Las Vegas Strip.

The Pair-O-Dice Club is pictured while under construction in 1930. The club, owned by Frank and Angelina Detra, opened as a private nightclub along Highway 91. In those days, Highway 91 was little more than a two-lane highway surrounded by desert. When gaming was re-legalized in 1931, the Detras applied for and were granted a gaming license. Within the month, the Pair-O-Dice Club became a public venue. It featured an intricate swamp cooling system and a gourmet Italian restaurant. The food was served on fine china with real silver utensils. The real linen tablecloths and lace napkins were designed by Angelina Detra. The facade was Spanish with rounded archways, a tile roof, and an octagonal-shaped entryway. There was a big band and dancing nightly. In 1938, the Detras sold the property to Guy McAfee, a former vice squad captain from Los Angeles, California. He renamed it the 91 Club, replaced the gourmet Italian food with affordable steak dinners, and emphasized gambling. The El Rancho Vegas opened 1 mile north in 1941. (NSM, LV.)

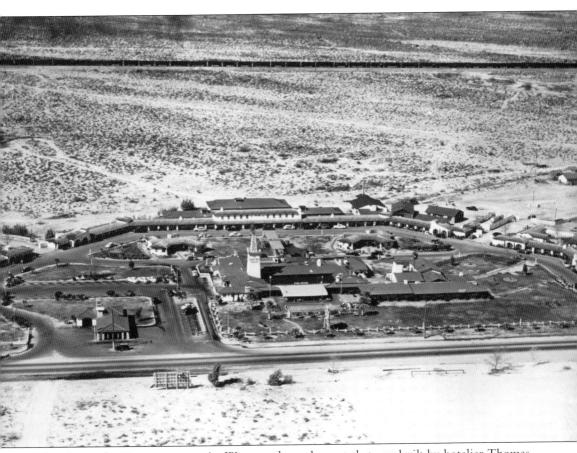

The El Rancho Vegas was a rustic, Western-themed resort that was built by hotelier Thomas Hull. Hull had been convinced by "Big Jim" Cashman to construct a hotel in Las Vegas. Cashman wanted Hull to build it on Fremont Street, but when it came to time to purchase the land, Hull discovered that the area along Highway 91, outside city limits, was cheaper. He built his hotel at the intersection of Highway 91 (today's Las Vegas Boulevard South) and San Francisco Street (today's Sahara Avenue). The ranch-style property sat on 33 acres surrounded by desert. Architect Wayne McAllister designed the resort with an eye toward the automobile driver. The Stage Door Steakhouse offered an affordable menu, and the Nugget Nell Cocktail Lounge offered free entertainment nightly. The Opera House showroom seated 300 and had wagon wheel chandeliers. Unlike Fremont Street, where the emphasis was on gambling, Hull wanted his guests to feel like they were on vacation and cared for by his attentive staff. An early morning fire destroyed the El Rancho Vegas in 1960.

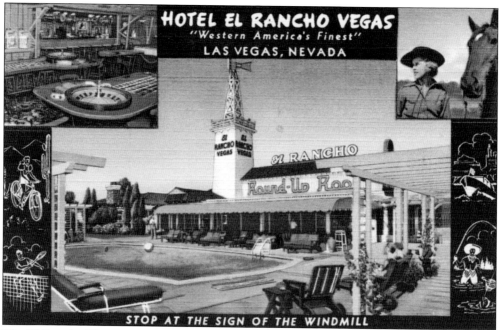

HOTEL EL RANCHO VEGAS
"Western America's Finest"
LAS VEGAS, NEVADA

STOP AT THE SIGN OF THE WINDMILL

The El Rancho Vegas pioneered many of the concepts still in use today. The swimming pool could be seen from the highway, and in the hot summer months, the blue turquoise water beckoned weary travelers to come in and stay awhile. Besides the private bungalows, the two hotel wings allowed motorists to drive up to their rooms and park their cars nearby. The manicured walkways and landscaping invited patrons to walk around the grounds. The casino was just off the hotel lobby. The chuck wagon buffet was born at the hotel as a way to offer cheap food to gamblers late at night who would rather keep courting Lady Luck than sleep. Hull hired a troupe of showgirls to entertain in the showroom, and Garwood Van's Orchestra was hired for four weeks and ended up playing for more than 13 months.

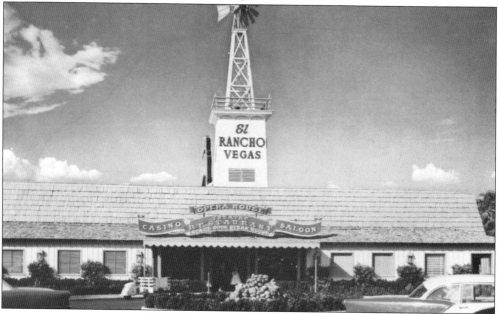

The El Rancho Vegas put the pool right out front where it could be seen by passing motorists. Back then, Highway 91 was a rough, potholed, two-lane blacktop road that was nothing like the sleek interstate freeways of today. Crossing the desert from Los Angeles, California, was a multi-hour adventure. In those days, radiator bags were a necessity to keep cars from overheating and to provide some cool air to the passengers. Tommy Hull had a string of hotels throughout California, including the Roosevelt Hotel in Hollywood. Because of his connections, he brought top-drawer entertainment to the Opera House showroom. For the cost of dinner and a two-drink minimum, guests could see such entertainment legends as Sophie "Last of the Red Hot Mamas" Tucker, comedian Joe E. Lewis, Milton Berle, the Ritz Brothers, and many others.

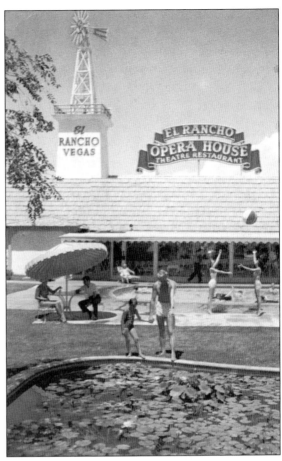

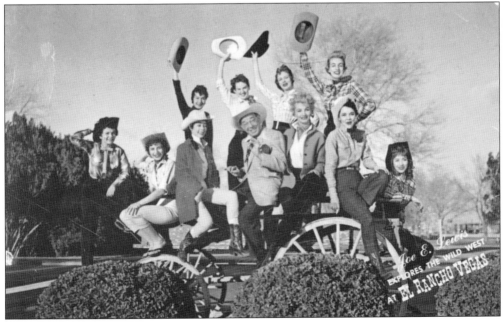

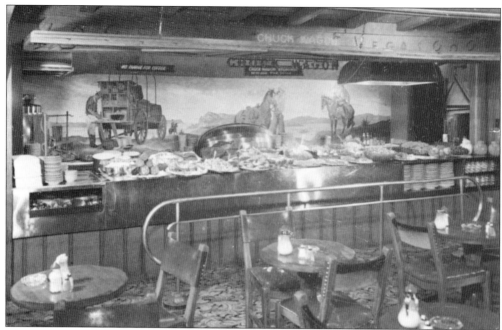

The El Rancho Vegas extended its Western motif to the interior design of the casino. The chuck wagon buffet was held in a room that had a large Western mural behind where the food was laid out. As the 1950s ushered in a new era of decor, the El Rancho Vegas did not abandon its Western roots. It replaced its wagon wheel chandeliers with more modern looking lighting fixtures. In the Nugget Nell cocktail lounge, the gaming motif was extended up to the roulette wheel dome in the ceiling. The El Rancho Vegas pioneered lounge entertainment from dusk to dawn. Lounge acts such as the Mary Kaye Trio and the Treniers would keep the lounge hopping all night long. Gamblers could leave their wives or girlfriends in the lounge to enjoy the music while they continued playing at the tables.

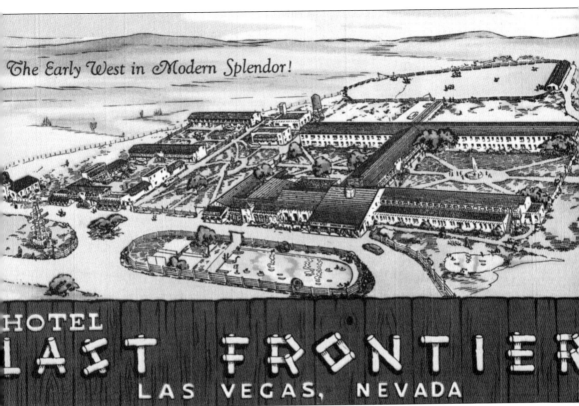

The Early West in Modern Splendor!

HOTEL LAST FRONTIER
LAS VEGAS, NEVADA

The Hotel Last Frontier was the vision of theater magnate R. E. Griffiths and his nephew, architect William Moore. They were on their way to California to purchase building material for a resort they were planning in Deming, New Mexico, when they saw the El Rancho Vegas under construction. Tommy Hull's resort hotel was rising alone on the dusty highway except for a few bars and saloons. Griffith and Moore thought there was room for at least one more resort. "We came to Las Vegas and found that the opportunities were fabulous," Moore recounted in his oral history. They scraped their plans for the resort in Deming and decided to build on property just south of the El Rancho Vegas. They figured if they built there, travelers on the Los Angeles Highway would see their resort first and be tempted to pull in instead of at the El Rancho Vegas. They would offer "the early West in modern splendor" to their guests, a rustic setting with modern amenities.

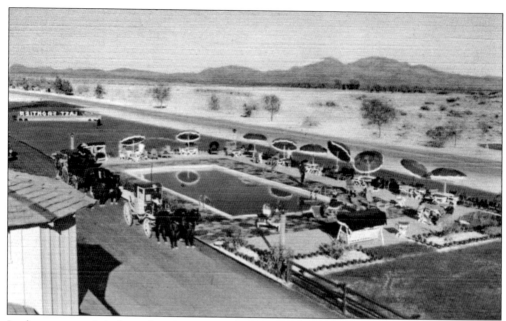

In these postcards is the swimming pool at the Hotel Last Frontier. It was placed right out on the front of the property. The two-lane, blacktop highway is visible. With the brightly colored umbrellas and sunbathers, motorists driving past caught quite an eyeful. A few years later, a privacy trellis was erected. The hotel opened in 1942, and the town turned out. Stagecoaches picked guests up from nearby Alamo Airport. Horseback riding was a big treat for those who wanted to experience the desert scenery. In 1947, the Last Frontier Village opened next to the resort. Unlike the sprawling exterior of the El Rancho Vegas, the Last Frontier was modeled more like a traditional hotel, albeit in Western style. Cold water circulated in tunnels under the hotel to cool it, with an individual unit in each room.

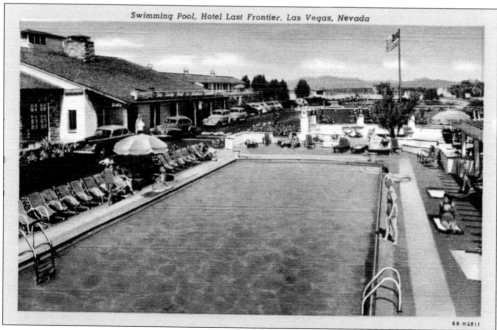

Swimming Pool, Hotel Last Frontier, Las Vegas, Nevada

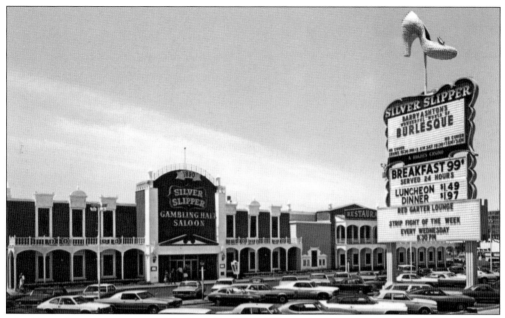

The Silver Slipper was part of the Last Frontier Village. Guests were encouraged to wager on an antique Wheel of Fortune that had reportedly been used in 19th-century mining camps. The Silver Slipper had the Flora-Dora Girls, a dance troupe in period costumes that performed nightly in the Old Bar. The giant silver slipper atop the sign was designed and fabricated by YESCO. It lit up at night and revolved. (NSM, LV.)

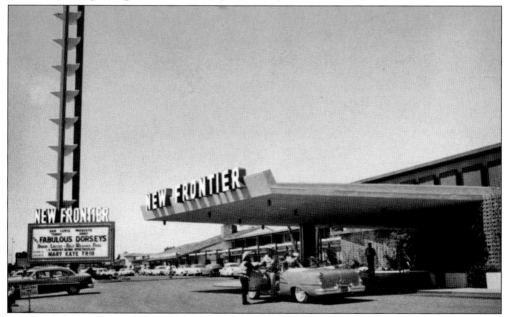

In 1954, it was decided that the hotel needed a complete makeover. To accomplish that, the New Frontier was built just north of the Hotel Last Frontier. The New Frontier was a two-story building with balconies and a welcoming porte cochere. The front lawn of the Hotel Last Frontier was paved over. The old buildings were ultimately demolished to make room for an expansion of the New Frontier.

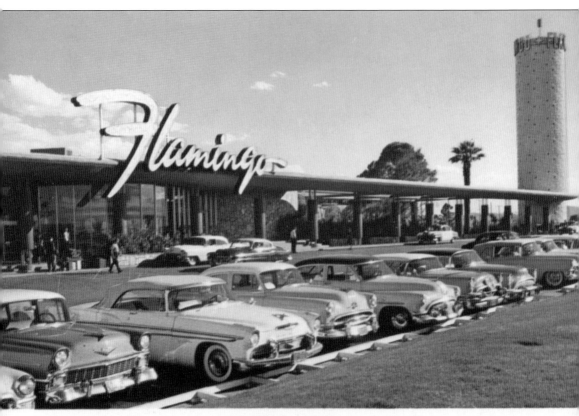

FLAMINGO HOTEL

The fabulous Flamingo Hotel, while steeped in a great deal of myth, was the first "carpet" joint on the Las Vegas Strip. Unlike the El Rancho and Frontier, the Flamingo was planned from the beginning not to be rustic or Western style. Both the original visionary, Billy Wilkerson, and the subsequent visionary, Benjamin "Bugsy" Siegel, envisioned a sophisticated modern resort that would cater to the Hollywood crowd and high rollers from around the world. Its original facade was simple with a pylon sign. There were no windows or clocks in the casino. Construction began in 1945 while building materials were still being rationed. The first opening on December 26, 1946, was disastrous due mainly to bad weather that kept many of the invited guests at home. In the early 1950s, to stay competitive, the Flamingo underwent a major makeover to a more modern look. The tower at the end of the porte cochere filled with neon champagne bubbles at night. The Flamingo has undergone many changes over the years but is one of a handful of original hotels still standing on the Las Vegas Strip today.

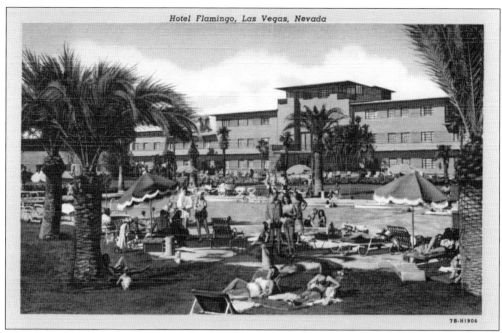

The area around the pool was lushly landscaped and offered guests a cool respite from the brutal summer sun. In the background is the Oregon Building. It was built as Siegel's personal living quarters. The fortress-like building had a bulletproof office and a secret tunnel, should Siegel need to escape would-be assassins. It was bulldozed in 1993.

Pearl Bailey was a well-known African American entertainer. Though she was a headliner, she was not allowed to stay in the hotel due to the segregation of the Las Vegas Strip. She could not eat in the hotel restaurants and had to take her meals in her dressing room. Each night when she finished her act, she had to travel across town to the Westside and stay in a boardinghouse. (NSM, LV.)

99

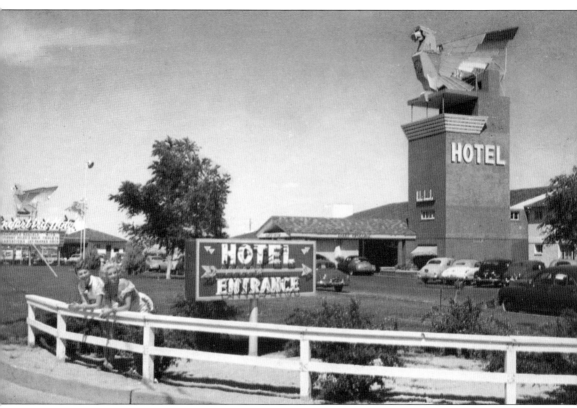

The Thunderbird Hotel was the fourth resort to open on what was becoming known as the Las Vegas Strip. It opened in 1948 to a packed house. A couple of well-known resort owners hit a winning streak and won so much at the tables that evening that they literally won the hotel away from owners Cliff Jones and Marion Hicks. Luckily for the two, a compromise was negotiated that allowed them to keep the hotel. It had the first porte cochere. It also helped that the newly designed McCarran Airport opened that same year. The giant neon bird sat atop the observation tower with its giant talons seeming to grip the top of the tower. The neon bird displayed all the colors of the rainbow and made a fitting mate for the nearby neon Flamingo. The signage was created by the Graham Neon Sign Company. With a nearby Mobile station and its neon Pegasus, and the neon windmill atop the El Rancho Vegas, the Las Vegas Strip seemed to be built for the automobile traveler.

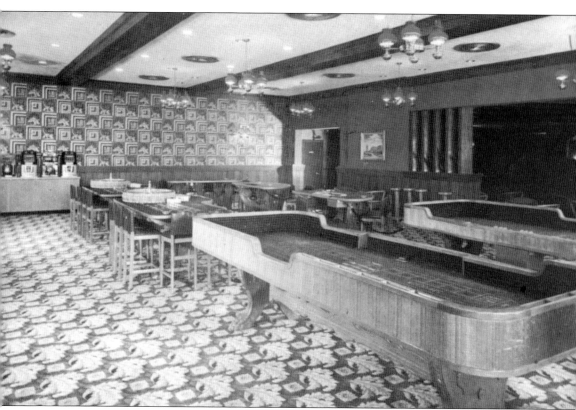

The interior of the Thunderbird looks quaint by today's mega resort standards. However, in that era, it was considered a luxury resort. The two partners, Cliff Jones and Marion Hicks, decided on the name Thunderbird, which was based on a Navajo legend. The interiors, designed by Hicks, carried this theme throughout the hotel. Warm, earthen colors were used, and the walls were decorated with Indian portraits. The Wampum Room, the Wigwam Room, the Navajo Room, and others also contributed to the Southwestern feeling. In 1955, the owners expanded the casino, moving it out toward the road. They built a second floor that was framed with a rectangular box. A new porte cochere was added, as well as a taller sign pole with three pennant signboards attached. Investor Joe Wells built a racetrack behind the hotel, aptly called Thunderbird Downs. The five-eighths of a mile track hosted both thoroughbreds and quarter horses. It had pari-mutuel betting and bleachers.

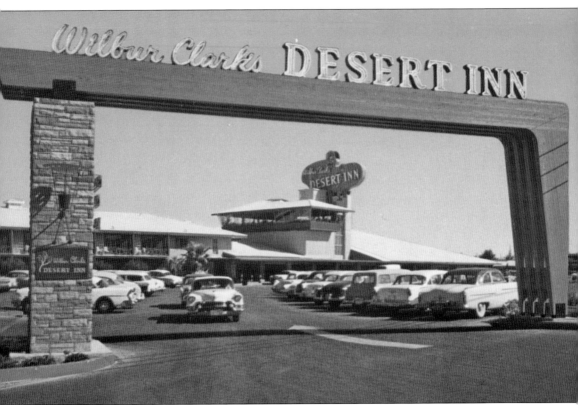

Wilbur Clark's Desert Inn was the first resort to incorporate the owner's name in the title. Clark was a shrewd businessman with big dreams. He imagined designing and owning a major resort on the Las Vegas Strip that would cater to high rollers and provide the best in entertainment. His dream resort became the Desert Inn, named after a hotel that he liked in Palm Springs, California. Construction began in 1947. He and his wife, Toni, along with a small group of friends, lived in a small motel while Clark searched for the financing to complete his dream. They would visit the site regularly and give Clark pep talks that kept him going. They celebrated holidays, birthdays, and anniversaries in that small hotel, never letting Clark give up on his dream. Clark soon ran into financial difficulties and had to take on partners. One of those partners was Moe Dalitz, who had ties to the Cleveland mob. Clark no longer owned a controlling interest in the hotel, but his name was forever associated with the property.

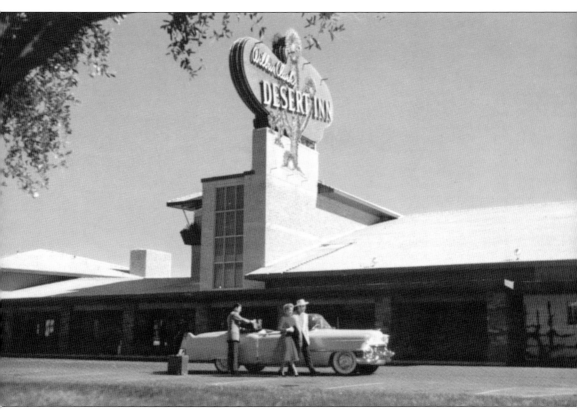

A circular drive led up to the entrance, which was a broad porch lined with ashlar pillars and lounge chairs. In the middle of the lawn was a fountain that sprayed water 60 feet into the air. Designed by Wayne McAllister and Hugh Taylor, the weeping mortar and native stone were composed in a clean-lined modern design, half ranch house, half nightclub. The stone was Bermuda pink with green trim. The hotel wings were interspersed around the pool patio with the parking lots behind the main building. While Clark, Dalitz, and Taylor never planned for the Desert Inn to be anything but a hotel, the majority of the clientele came by automobile. The cinder block structure had a sandstone veneer quarried in Arizona and Nevada. Redwood was used throughout the interior, and the flooring was made of flagstone. The entire resort was air-conditioned with the innovation of individual thermostats in each room. The fanciful neon sign was designed by YESCO'S Hermon Boernge and featured a Joshua tree "cactus," a species found not in Southern Nevada but in Arizona.

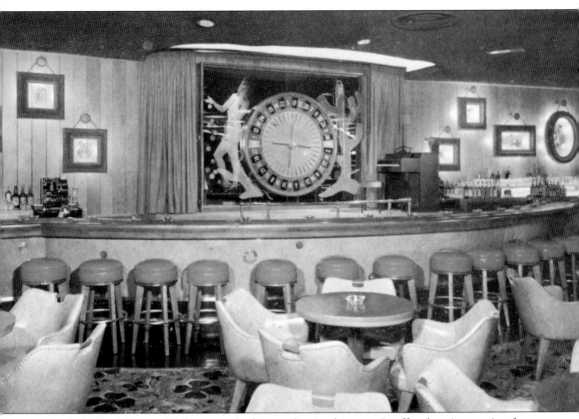

The Lady Luck Bar, at 90 feet, was the longest bar in the state. It offered an innovative form of gambling embedded in the bar itself. Before each patron was a circle of numbers resembling a roulette wheel. A corresponding roulette wheel was displayed in the center of the bar area on the wall located above a nude figure representing Lady Luck. Every hour the wheel would spin, and the patron whose light flashed would win the shower of silver dollars falling from the nude's hands. A tremendous wood-burning fireplace, set corner wise, added to the warmth but in no way interrupted the view of the center patio and landscaped gardens through one entire glassed-in wall. The turquoise-blue figure-eight pool was ringed by the motel wings with cabanas. Inner tubes all had "Wilbur Clark's Desert Inn" emblazoned on them. At the north end of the pool was the Kachina Doll Ranch with a day care center staffed by a psychologist. There was a playground adjacent to keep the kiddies occupied. The room rate was $5 and up.

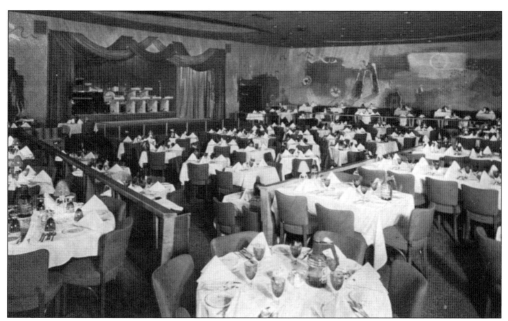

The showroom at the Desert Inn was the Painted Desert Room. It was a 450-seat showroom with hand-painted murals by Charles Cobelle. The Painted Desert Room boasted a "band car" that mechanically whisked the orchestra on and off the stage in one motion. The lighting was soft and indirect. The menu featured Western flora and fauna on the cover. Entertainers who graced the stage included Frank Sinatra in the era before his award-winning role in *From Here to Eternity*. Sinatra used to quip, "For six bucks you got a filet mignon dinner and me." Donn Arden, the famed choreographer, created elaborate stage shows. These extravaganzas involved chorus girls and showgirls, alike, dressed in elaborate costumes, and the shows had epic story lines such as the American immigrant experience and the sinking of the *Titanic*.

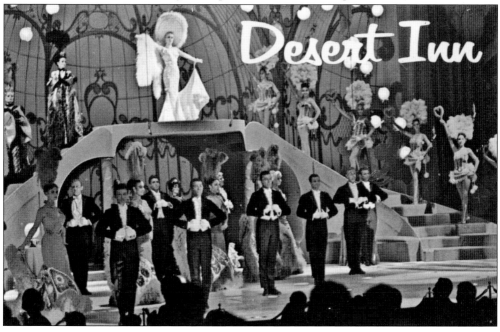

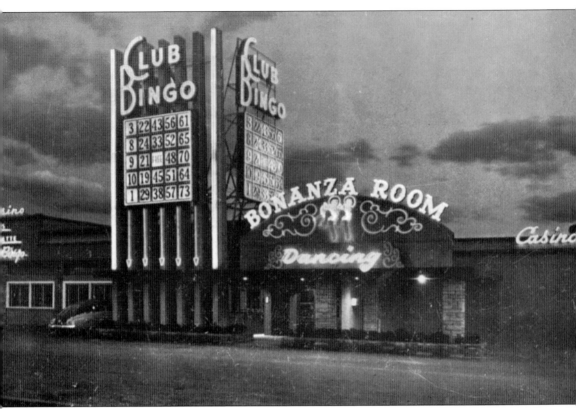

Club Bingo was the predecessor to the Sahara Hotel. Fred Schivo was a longtime gamer who had the idea for Club Bingo, a 300-seat bingo parlor. He had to find investors that would be willing to take the financial plunge. He lucked out when he met Milton Prell from Butte, Montana. Prell had operated the 30 Club in Butte, but like many other gambling visionaries of the day, he relocated to the friendly climes of Las Vegas in the 1940s. Though not as well known today as others, such as Wilbur Clark and Del Webb, Prell nonetheless made an impact on Las Vegas. Club Bingo opened on the rainy day of July 24, 1947. In addition to the bingo parlor, there were a few other games of chance, and Club Bingo had a reputation for fine food in its Bonanza Room as well. There were no hotel rooms because the club was just for gambling and fine dining, but it did have a small showroom that showcased the talented Dorothy Dandridge, comedian Stan Irwin, and the Treniers. (NSM, LV.)

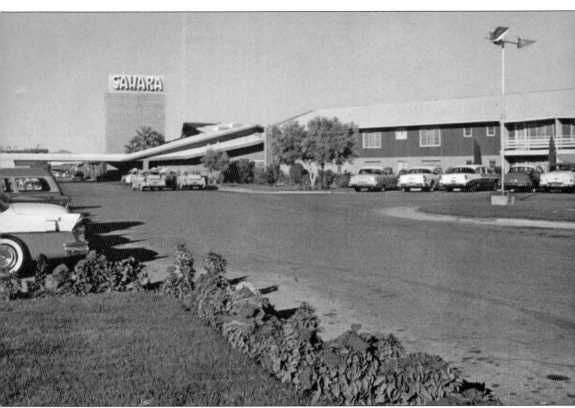

Milton Prell soon realized that the future of the Las Vegas Strip was in having a resort hotel that catered to the tourists swarming in from Southern California, which meant financing the building of a major hotel. The Sahara Hotel soon became a reality. The architect was Max Maltzmann, and the designer was Albert Parvin. It featured a tall brick pylon at the entry, which anchored the low wings that spun outward from its center like a pinwheel. The motif was similar to the Arizona Biltmore in Phoenix, designed by famed architect Frank Lloyd Wright. There the sculptural elements of the textile block provided ornament. At the Sahara, the signage became the ornament. The theme was North Africa. Statues of camels and nomads dotted the facade. Originally set to open in the summer of 1952, the Sahara officially opened on October 7, 1952. Construction delays were the cause for pushing back the date. The headliner for the opening was Ray Bolger, who had starred as the Scarecrow in the *Wizard of Oz*.

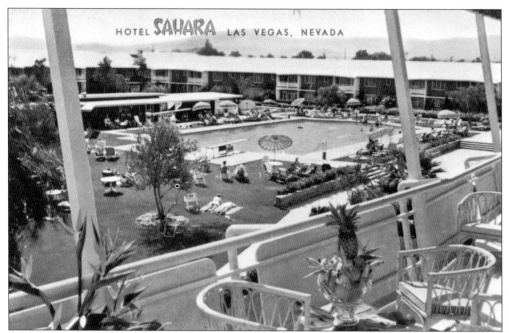

The Caravan Room Coffee Shop looked out over the pool terrace. Glassy restaurants, such as the Caravan Room, looked out not only on the pool area but also on the well-manicured and landscaped lawns. Lucius Beebe gushed, "It's twenty acres of landscaped ground with rare blossoms and shrubs to make even Boston's Public Gardens look to its tulips."

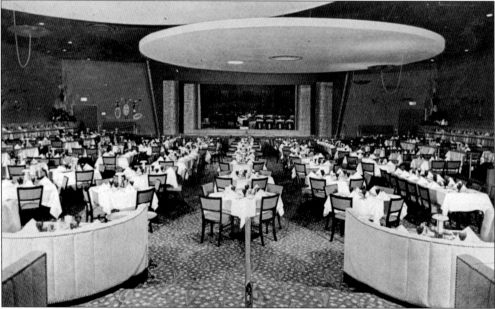

The Congo Room was the showroom for the Sahara Hotel. Over the years, entertainers such as Ray Bolger, Marlene Dietrich, Johnny Carson, Mae West, and many others graced the stage. The showroom, it was claimed, was the first room to be terraced for ringside visibility. The Casbar Room was the lounge where Louis Prima, his wife Keely Smith, and Sam Butera and the Witnesses revolutionized lounge entertainment in the mid-1950s.

As the 1960s were ushered in, the Las Vegas Strip was growing at a steady rate. Tourists and gamblers were visiting more, and the hotels, taking a tip from the Riviera with its high-rise tower, began going vertical to increase the number of rooms they could offer. Designed by Los Angeles architect Martin Stern Jr., the expansion included a convention hall on the Sahara's north side, as well as a 127-foot vertical roadside sign designed by the artists at YESCO. The new 14-story, high-rise tower sat on the far side of the pool and was patterned with windows, balconies, and stair towers that imparted a dynamic, sculptural quality. Atop the tower was a time and temperature board highlighted by a semi-Arabic "S" on the very top. In 1961, Milton Prell sold the Sahara to Del Webb. Webb merged his construction company with the Sahara-Nevada Corporation and became the first publicly traded company to have holdings in a Las Vegas gaming establishment.

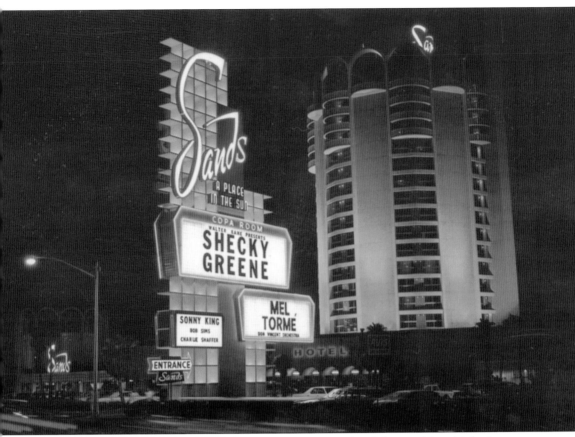

The Sands had opened in 1953, but by 1964, the owners realized the need for a high-rise tower. Architect Martin Stern Jr. was hired to design a new high-rise tower that would replace the original building. The new tower opened in the winter of 1965. They did keep the original roadside signage that original architect Wayne McAllister had designed. McAllister designed a 56-foot-tall (the "S" alone was 36 feet in height) sign, by far the tallest on the highway at that time. With its elegant modern script, the sign blended with the building to create a mid-20th-century modern paradise. The sign and the building had motifs common to both. The sign was fabricated by YESCO. With its egg crate grill, cantilevered from a solid pylon, it played with desert light and shadow. In bold free script, it proclaimed "Sands" in neon across the face. At night, it glowed red when the animated neon spelled out the name. (NSM, LV.)

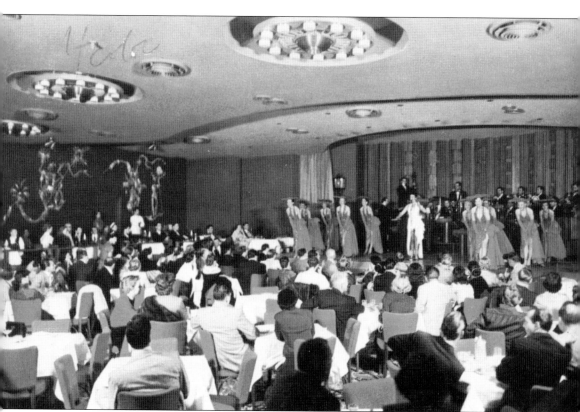

The Copa Room, the showroom for the Sands, is probably the most cherished room in collective memory. It was here that Frank Sinatra and his buddies held a series of nightly shows while, during the day, they shot the original *Ocean's 11*. For three weeks, the Rat Pack—as they were known—filmed their scenes during the day and then took the stage in the Copa Room for two shows nightly. It was known as "the Summit at the Sands," and it quickly became the hottest ticket in town. Audiences were never sure just who would be taking the stage each night and if the rest of the Rat Pack would be there as well. This only added to the excitement. Though it seemed as if the boys were ad-libbing their way through the evening, in reality, Joey Bishop wrote most of the material. The bar cart was wheeled on stage, and for the next two hours, one was never sure of what would happen next. Celebrities poured into town to see the freewheeling, seltzer-spraying shows.

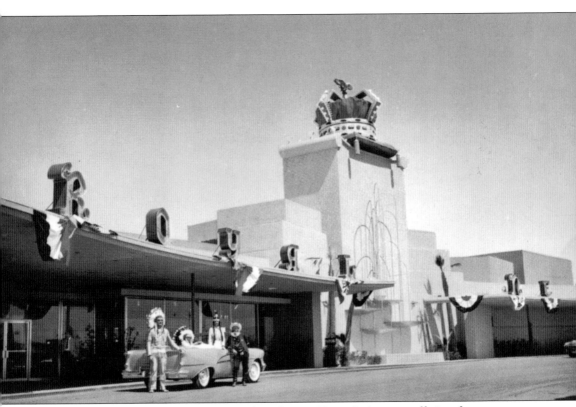

The Royal Nevada opened at a time when the Las Vegas Strip was suffering from too many rooms and not enough tourists to fill them. It would open within months of two other new resorts and would struggle to stay afloat. On the night before the official opening, the Royal Nevada had a preopening party for the atomic soldiers at the Nevada Test Site. The soldiers were bussed into town and given the run of the hotel and casino. The hotel officially opened on April 19, 1955. It was located just north of the New Frontier on the west side of the highway. Famed African American architect Paul Revere Williams designed the new hotel. Less than a year later, the hotel was shuttered until back wages were paid to the staff. In March 1956, the hotel reopened but still struggled to stay afloat. By 1958, the hotel was shuttered for good. The mid-1950s were a rough patch for the hotels on the strip. It was the only time that the number of rooms exceeded the number of tourists.

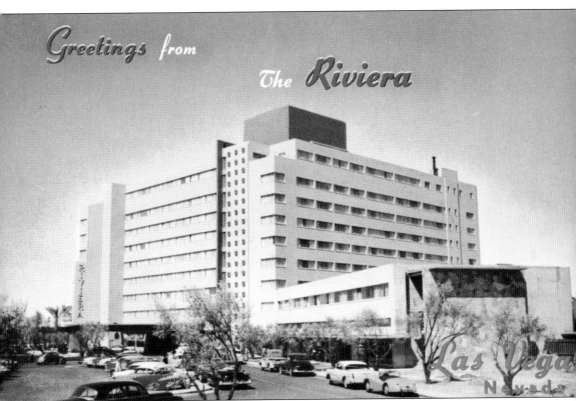

Greetings from The Riviera

Las Vegas Nevada

The Riviera created a stir before its doors ever opened. The hotel was to be a departure from the low-rise, two-story, garden-style motel rooms that had been popular since the early days of the 1940s. The Riviera was going vertical, nine stories into the air, as the first high-rise on the famed boulevard. With a price tag of $10 million, the hotel would have 291 rooms. A block with banks of horizontal strip windows marked the center of the tower. Wraparound windows delineating the corners were added. The contrasting elevator tower, with decorative gold buttons, definitely conjured up images of South Beach instead of the Southwest. The various floors were named after French resort cities such as Cannes, Monaco, and Nice. The ninth floor had penthouse suites and housed a health club. The lobby and front desk area featured Italian marble and corrugated cooper fixtures. The Starlight Lounge, just off the lobby, had a 150-foot, free-form stage bar. The Treniers opened the Starlight Lounge. With their high-energy show, the group kept the lounge jumping till the wee hours.

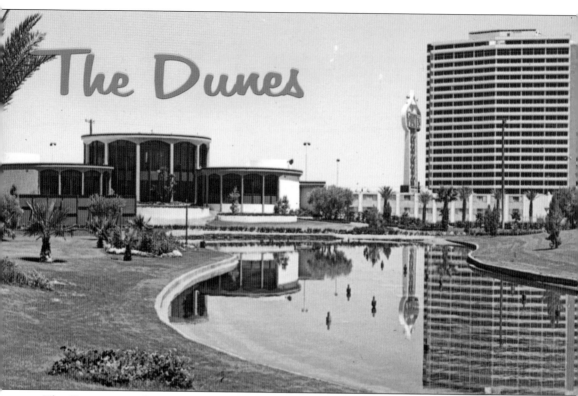

The Dunes opened on May 23, 1955. It was located catercorner across the highway from the Flamingo Hotel, and at the time, it was the farthest hotel out on the south end of the highway. By the early 1960s, it no longer held that distinction. A remodel was ordered. The ground-breaking for the "Diamond of the Dunes" tower was held on October 20, 1962. Gov. Grant Sawyer was on hand to help turn the dirt. Milton Schwartz, an architect from Chicago, designed the new tower. The Diamond of the Dunes would more than double the number of rooms available at the hotel. The addition was designed, like many of the older properties going vertical, for the tourist that arrived by jet. The thing that set the remodel of the Dunes apart was that it was part of a master plan for the resort. This master plan called for an additional five towers to be built over the years, with the intention of the Dunes becoming a major resort. The Dunes was imploded in 1993.

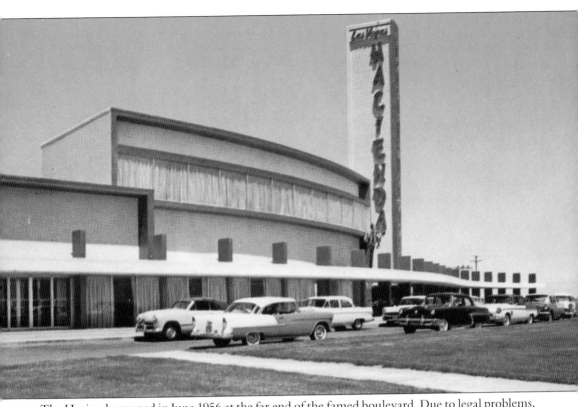

The Hacienda opened in June 1956 at the far end of the famed boulevard. Due to legal problems, it opened without a casino, and the hotel struggled to stay afloat. Finally, the owners were able to open the casino, but the property still struggled. It managed to stay open mainly due to junketeer Henry Price. Price flew tourists into town to stay at other hotels. But on the weekends, there were not enough rooms to accommodate those gamblers. Price approached owner Warren "Doc" Bayley about using the Hacienda for the overflow crowd, and Bayley agreed. Given its remote location compared to the other hotels, the Hacienda had to have a hook, and that hook was taking the family oriented angle. Las Vegas was known mainly as an adult playground, and the other hotels had some facilities for those traveling with their families but mainly catered to couples traveling without their children. The Hacienda went after the family market. To keep the children occupied while their parents gambled, Bayley added kid-friendly activities like a go-kart track. The Hacienda was imploded in 1996.

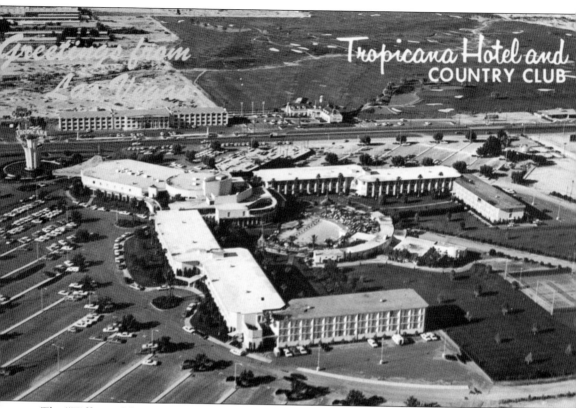

The "Tiffany of the Strip," as it was known, opened on April 4, 1957, with Lt. Gov. Rex Bell (a former film star) cutting the ribbon. The Tropicana was located on the south end of the Las Vegas Strip on the east side of the highway. It had a Y-shaped structure and luxurious landscaping. The hotel had what was called "Peacock Alleys" that ran from the mahogany-paneled lobby straight back to the elegantly decorated rooms surrounding the pool. Visitors could bypass the casino in this manner, which was anathema to other owners. The casino area was screened off from the lobby by live plants. Inside there were massive chandeliers, an elongated serpentine bar, mosaic inlaid tiles around the front entrance, and a special television room for children. Room rates started at $12 a day and went up as high as $50, which was expensive for 1957. It is estimated that the builders spent $1,265,000 in furnishings for the resort, which did not include the gaming equipment. The Tropicana is still open.

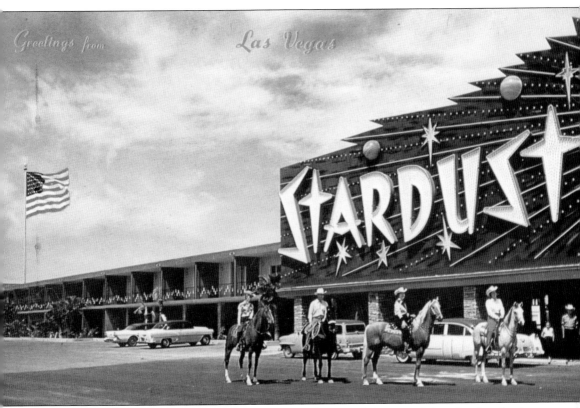

Abandoning the Old West themes and the more sophisticated signage of the other hotels, the Stardust Hotel promised the galaxy. It also needed signage that matched the optimistic future of its name. YESCO's Kermit Wayne went for broke and put the entire solar system across the front of the hotel that exploded out toward the edges. At the facade's center was a large plastic earth that was 16 feet in diameter formed in slices 3 feet across and ringed by a Sputnik, which was right off the front page of the daily papers. Cosmic rays of neon and electric lightbulbs pulsed out from behind the earth in all directions. Passing motorists had to be engaged as they approached the resort. Because the Stardust was surrounded by desert, the owners were afraid that at night the hotel would be hard to see. Three-dimensional planets spun into the night alongside 20 neon starbursts. Plastered across this universe, in space-age lettering that became iconic, were the letters "Stardust." The "S" alone contained 975 lamps. (NSM, LV.)

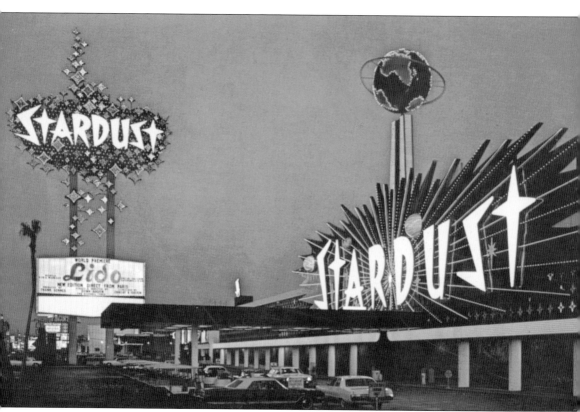

The Stardust was the last hotel to be built on the Las Vegas Strip in the 1950s. Its arrival was also heralded by the older properties' remodeling and renovating. Everybody, it seemed, needed more hotel rooms, more space, and more machines. The Old West theme was almost gone from the landscape as older hotels raced to embrace the space-age theme. The Stardust's owners had bought the shuttered Royal Nevada Hotel and incorporated the building, hotel rooms, and swimming pool into the Stardust. In 1964, they placed a neon-rimmed globe atop the galaxy facade. They also spent $500,000 on the design and fabrication of a new roadside sign. The sign suggested something beyond itself. Its form was blurred by a scattering of star shapes around its periphery. It depicted, in fact, a shower of stardust. At night, the sign was animated, and light fell from the stars atop the 188-foot sign downward over the Stardust name, which was emblazed across the middle, and then the stars continued to shower downward to the marquee board. The Stardust was imploded in 2006.

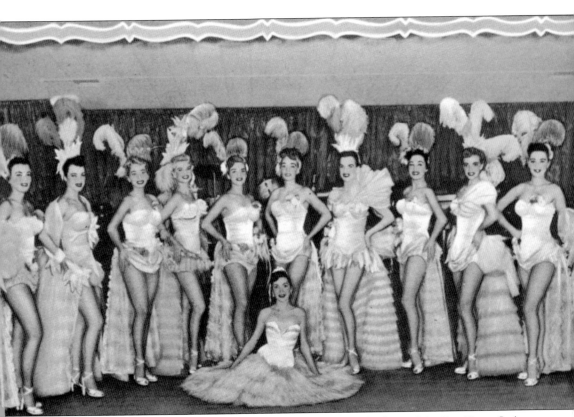

This is the chorus line for the Hotel Last Frontier. In the early days of the Las Vegas Strip, each hotel had a lineup of chorus girls that would open the nightly entertainment in the showroom. The women would do a few musical numbers and warm the crowd up for the comedian that usually followed. The chorus line consisted of pretty young girls with good figures. They would often back up the headliner as well, especially entertainers like Donald O'Connor and Ray Bolger. Their costumes were a bit risqué to show off their best assets. As the 1940s gave way to the 1950s, the chorus girls got taller and more curvaceous. Jack Entratter, the entertainment director at the Sands Hotel, would attend auditions around the country looking for the dancers to become the famed Copa Girls. The women were not allowed to leave the hotel between shows, and while some stayed in their dressing rooms, others mingled with guests. The women had a head mistress/seamstress who oversaw their costume changes and acted as a den mother. (NSM, LV.)

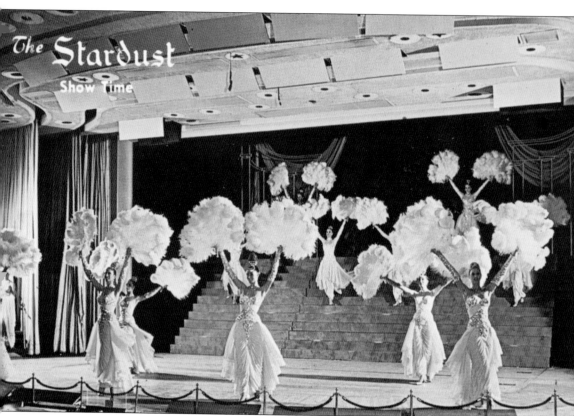

The Lido de Paris spectacular at the Stardust Hotel was in the Continental Room, which provided seating for 700. The Lido de Paris was the largest production show produced on the Las Vegas Strip at the time. It featured the world-famous Bluebell Dancers, direct from England. They were overseen by Madame Bluebell, a friend of Frederic Apcar's from France. She came from Paris at the invitation of hotel management to help create the Lido de Paris for the resort. She required her dancers to have extensive ballet training, they had to be 5 feet, 8 inches tall or taller, and they had to be long legged and beautiful. Dancers from the Lido Club in Paris were brought over to be part of the show. Though the show was created by producers Pierre-Louis Guerin and Rene Fraday at the Lido Club in Paris, the man in charge of the staging and production was the unquestioned master of the stage spectacular, Donn Arden. Las Vegas show goers had not seen anything like at it at the time.

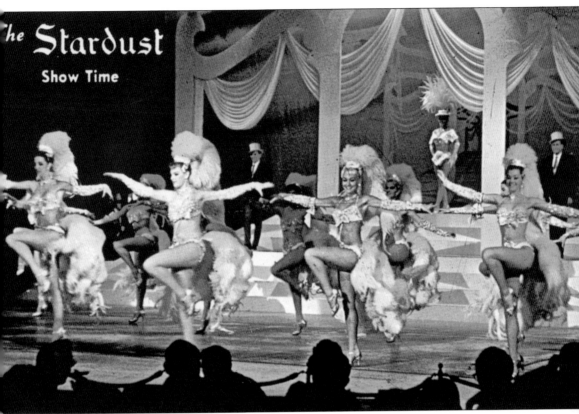

Perhaps there is no better remembered icon of those halcyon days like the bejeweled, feathered showgirl. The unions were strict about the number of European performers and dancers who could be allowed to dance in a show. The costumes were all made in Paris and were rented at a cost of $600,000 to avoid the 40 percent duty that would be imposed if they were bought outright and shipped to Las Vegas. Donn Arden was the genius behind the magic. Arden had been creating stage fantasies since he was 15. He loved spectacle, drama, and tragedy. He first staged the sinking of the *Titanic* for the Lido, as well as the San Francisco earthquake. He was the first producer in town to take the nudity of Minsky's Burlesque and incorporate into a dramatic setting. Up till then, Americans had been used to seeing nudity in burlesque and in the bump-and-grind joints that were scattered about the country. But Donn Arden took nudity to a whole new level and art form by introducing it as part of a dramatic stage spectacle.

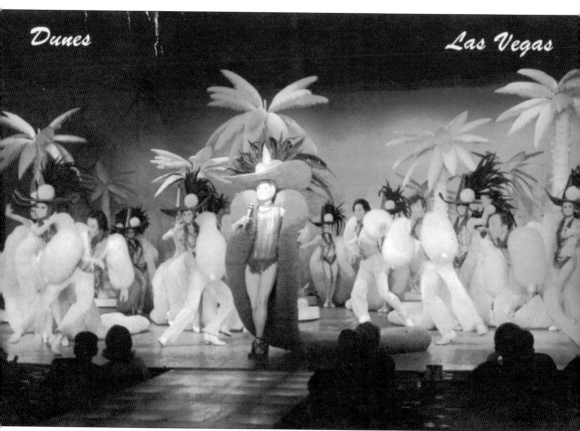

The success of the Lido de Paris at the Stardust caught the attention of entertainment directors up and down the Las Vegas Strip. The cost to keep the A-list of entertainers signed to individual hotels was rising. The Dunes Hotel, which had never had great success with its showroom, decided to follow the example of the Stardust and create a production show filled with beautiful dancers. The owner, Major Riddle, approached Frederic Apcar about the possibilities. Apcar suggested that the famed Casino de Paris be brought over. With a little convincing, Henri Varna, the producer of the show in Paris, agreed to the deal. Apcar went to work on producing an authentic version of the show. An octagonal-shaped stage was designed and built in Scotland for the show, and French singer Line Renaud was brought over to headline it. For one particular number in the show, she entered from the back of the house because the train of her Jose Luis Vinas costume stretched from there to the stage.

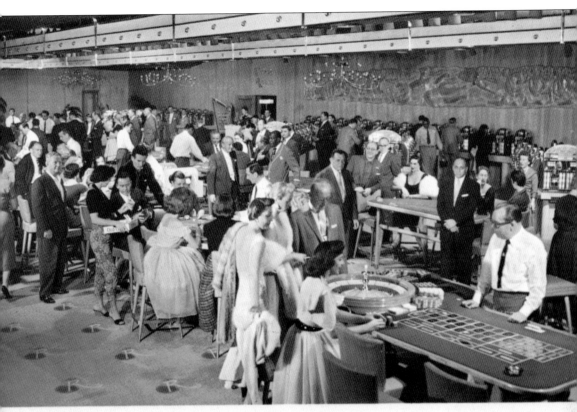

LAS VEGAS HAS THE WORLD'S MOST BEAUTIFUL CASINOS

It can be hard to imagine in this era of comfortable clothes and casual Fridays that there was an era when men and women dressed up to go out. In the beginning, when people traveled to Las Vegas, the men would wear a suit and tie and the women a nice dress and perhaps gloves. Women did not wear pantsuits, and no one wore jeans unless it was during Helldorado Days. As the 1950s evolved, the showrooms had a dress code that required a sports jacket and tie. Women and men began bringing outfits that they would not necessarily wear at home but were acceptable in Las Vegas. Fur coats, mink stoles, and low-cut beaded evening gowns were not only for the showrooms as women dressed to the nines to go down to the casino to gamble. By the early 1970s, dressing up to go out was still de rigueur, but the old standards were breaking down. By the end of the decade, people would be wearing jeans and shorts in greater numbers than those dressed up for a night on the town.

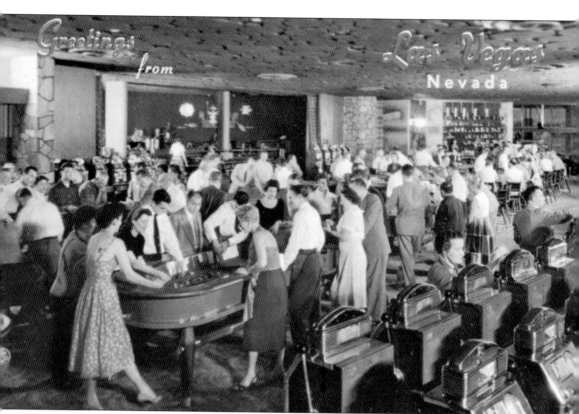

Today visitors are used to mega resorts and the latest technology in gaming machines. Looking back at postcards of the way it once was can be disconcerting. The casinos look so small, so empty, and so quaint. But remember that in their day, the casinos of Las Vegas were at the top of the pyramid in terms of luxury, and they were wired in to the latest technology. Perhaps it was just low-tech by today's standards. A look back reminds one of the way life used to be. This casino postcard certainly makes it look less hectic and more relaxing. Remember that compared to today's massive casinos, the original casinos were small and intimate. Only a couple of rows of slot machines, a couple of blackjack tables, and a few craps tables were the most popular games of chance.

At the time it was built, the Tod Motor Motel sign could be seen from almost anywhere in the Las Vegas valley. The Tod's location was convenient to restaurants, shopping, and the casinos on the Las Vegas Strip and in the downtown area, making it a popular destination for visitors. The sign still attracts visitors who yearn for a piece of classic Las Vegas.

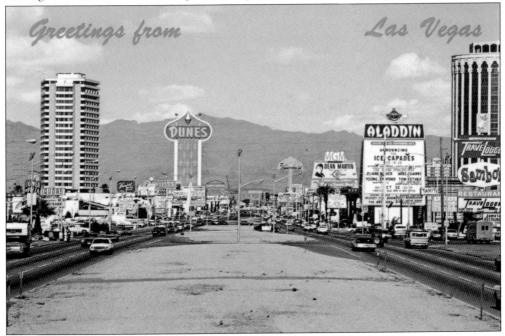

The south end of the Las Vegas Strip reminds one of the old ways. Traffic flows along both sides of Las Vegas Boulevard. Along the old highway are motels, a Sambo's, gas stations, the Tower of Pizza, and the wonderful neon signs. These signs tower over the traffic below, giving a sense of scale.

This is a postcard from Diamond Jim's in the Nevada Club. In addition to picture postcards, some establishments used print advertisements to catch the eye. Usually found at the reception desk or near the cashier's cage, the postcards were there for visitors to use to encourage their friends and family that they really needed to take a trip to Las Vegas. There really was no place like it on earth. (NSM, LV.)

BIBLIOGRAPHY

Green, Michael and Eugene Moehring. *Las Vegas: A Centennial History.* Reno, NV: University of Nevada Press, 2005.

Hess, Alan. *Viva Las Vegas: Architecture after Dark.* San Francisco: Chronicle Books, 1993.

Moehring, Eugene. *Resort City in the Sunbelt.* Reno, NV: University of Nevada Press, 2000.

Nichols, Chris. *Leisure Architecture of Wayne McAllister.* Salt Lake City: Gibbs and Smith, 2007.

Ripella, Heidi Knapp and Mike Weatherford. *The Stardust of Yesterday.* Las Vegas: Stephens Press, 2006.

Whitely, Joan Burkheart. *Young Las Vegas: Before the Future Found Us.* Las Vegas: Stephens Press, 2005.

Wright, Frank. *Nevada Yesterdays.* Las Vegas: Stephens Press, 2005.

www.classiclasvegas.com

www.classiclasvegas.squarespace.com

www.onlinenevada.org

Across America, People are Discovering Something Wonderful. *Their Heritage.*

Arcadia Publishing is the leading local history publisher in the United States. With more than 4,000 titles in print and hundreds of new titles released every year, Arcadia has extensive specialized experience chronicling the history of communities and celebrating America's hidden stories, bringing to life the people, places, and events from the past. To discover the history of other communities across the nation, please visit:

www.arcadiapublishing.com

Customized search tools allow you to find regional history books about the town where you grew up, the cities where your friends and family live, the town where your parents met, or even that retirement spot you've been dreaming about.